HIDDEN ALASKA

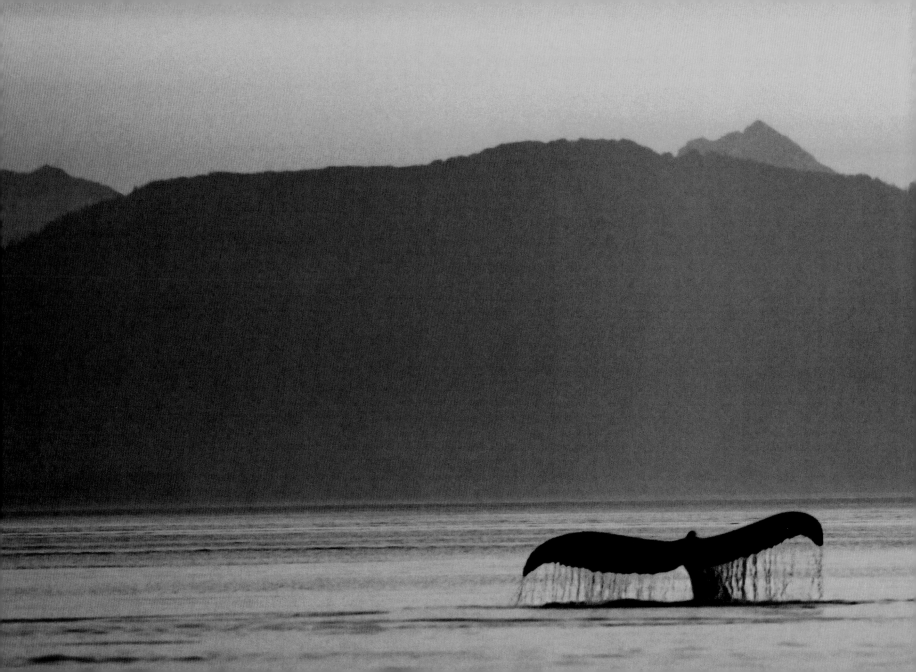

HIDDEN ALASKA
BRISTOL BAY AND BEYOND

PHOTOGRAPHY BY MICHAEL MELFORD

TEXT BY DAVE ATCHESON

NATIONAL GEOGRAPHIC

Washington, D.C.

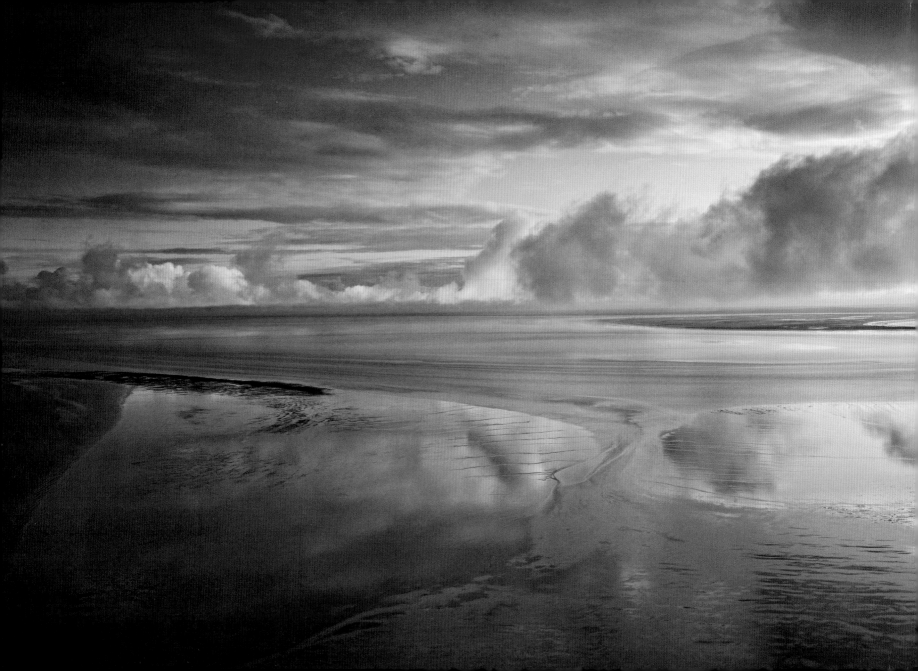

CONTENTS

My love affair with Alaska started years ago with two assignments. One was camping on the Ruth Glacier in the shadow of Denali, the highest mountain in North America, and spending the days climbing, skiing, and photographing in that spectacular amphitheater surrounded by 1,000-foot granite cliffs. The second assignment was sailing the clear waters of Prince William Sound, which is ringed by the coastal range of the Chugach Mountains and massive glaciers that stretch down to the sea.

I had found America's last frontier, a heaven on earth, both wild and pristine. After many more trips, I have now photographed puffins in the Pribilof Islands, caribou in the Brooks Range, and salmon just about everywhere. I've had close encounters with huge brown bears, bald and golden eagles, breaching humpback whales, and masses of walruses and Steller sea lions. I've flown in bush planes over Gates of the Arctic, Misty Fiords, Bering Land Bridge, Yukon-Charley Rivers, Glacier Bay, Denali,

Wrangell-Saint Elias, Lake Clark, and Katmai National Park. I've slept—lightly—while listening to the Hubbard Glacier as it constantly calved through the night.

My most recent trip to Alaska had me on a mission to record the area surrounding Bristol Bay for *National Geographic* magazine. This is a part of Alaska unknown to the average tourist cruising the Inside Passage and, if they are lucky, viewing Denali. No, Bristol Bay is located on the back side of the Aleutian Islands in Southwest Alaska and rarely visited by casual travelers.

Avid sport and commercial fishermen know of Bristol Bay. It is the waterway where 44 million salmon of all five species return each year to spawn and die.

The salmon are the heartbeat of the bay, both defining and supporting it. For centuries the local Yupik and Aleut tribes have harvested the salmon, smoking and preserving them as their primary food for winter sustenance.

But the large brown bears, beluga whales, and eagles also partake in, and depend upon, the harvesting. All this richness is possible only because the area of Bristol Bay has remained pristine and because the state's Department of Fish and Game has put in place procedures that promote the sustainability of the fish population.

Surrounded by Katmai National Park and Preserve, Lake Clark National Park and Preserve, Wood-Tikchik State Park (the largest state park in the United States), and Togiak National Wildlife Refuge (the summer residence of 10,000 male walruses), the land is primarily the same as it has been for centuries. At the center of this amazing area is a highway of water that is used by the salmon, as well as the trout, fishermen, and beluga whales that pursue them. Two rivers flow into Bristol Bay: the Nushagak, which has the largest run of king salmon in the state, and the Kvichak, which flows out of Iliamna Lake, the largest lake in Alaska. The tributaries of these two rivers run throughout the area, and two of

them almost meet at a spot that contains the largest deposit of gold and the sixth largest deposit of copper in the world. A newly proposed large-scale mining project now threatens this area's fragile ecosystem. It is the classic question of what to do when the demands of capitalism and commercial gain come face-to-face with the needs for conservation and preservation. Which force will prevail is yet to be seen.

I was sent to Bristol Bay by *National Geographic* magazine to chronicle the impact of a mining operation there, but I brought back this book, a celebration of Bristol Bay and Alaska. It has been my unique privilege, and joy, to be able to visit and photograph this incredible landscape. My hope is that you will be as astounded by the beauty of this area as I have been, and that it will encourage more of us to conserve what is left of this last great American wilderness.

—Michael Melford

FOREWORD

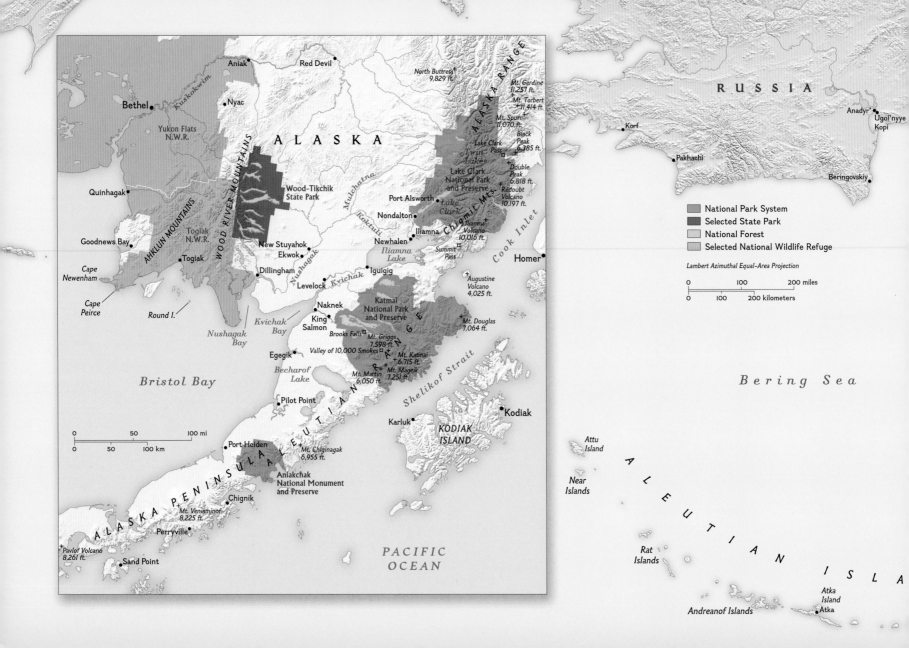

RUSSIA

Anadyr'

Ugol'nyye Kopi

Korf

Pakhachi

Beringovskiy

Aniak

Red Devil

North Buttress 9,829 ft.

A L A S K A R A N G E

Mt. Gerdine 11,257 ft.

Mt. Torbert 11,414 ft.

Mt. Spurr 11,070 ft.

Black Peak 6,385 ft.

Bethel

Nyac

Yukon Flats N.W.R.

A L A S K A

WOOD RIVER MOUNTAINS

Lake Clark Pass

Twin Lakes

Double Peak 6,818 ft.

Quinhagak

Wood-Tikchik State Park

Lake Clark National Park and Preserve

Redoubt Volcano 10,197 ft.

Mulchatna

Port Alsworth

Lake Clark

Chigmit Mts.

Nondalton

AHKLUN MOUNTAINS

Toglak N.W.R.

Goodnews Bay

Koktuli

Iliamna

Iliamna Volcano 10,016 ft.

New Stuyahok

Ekwok

Newhalen

Summit Pass

Toglak

Iliamna Lake

Cook Inlet

Cape Newenham

Dillingham

Nushagak

Kvichak

Iguigig

Homer

Levelock

Augustine Volcano 4,025 ft.

Cape Peirce

Round I.

Nushagak Bay

Kvichak Bay

Naknek

King Salmon

Katmai National Park and Preserve

A L E U T I A N R A N G E

Mt. Douglas 7,064 ft.

Brooks Falls

Mt. Griggs 7,598 ft.

Valley of 10,000 Smokes

Mt. Katmai 6,715 ft.

Egegik

Becharof Lake

Mt. Martin 6,050 ft.

Mt. Mageik 7,251 ft.

Shelikof Strait

Bristol Bay

Kodiak

Pilot Point

Karluk

KODIAK ISLAND

Bering Sea

Port Heiden

A L A S K A P E N I N S U L A

Mt. Chiginagak 6,955 ft.

Aniakchak National Monument and Preserve

Attu Island

Chignik

Mt. Veniaminof 8,225 ft.

Near Islands

A L E U T I A N I S L A

Perryville

Rat Islands

Pavlof Volcano 8,261 ft.

Sand Point

PACIFIC OCEAN

Andreanof Islands

Atka Island

Atka

Legend:
- National Park System
- Selected State Park
- National Forest
- Selected National Wildlife Refuge

Lambert Azimuthal Equal-Area Projection

0 100 200 miles
0 100 200 kilometers

0 50 100 mi
0 50 100 km

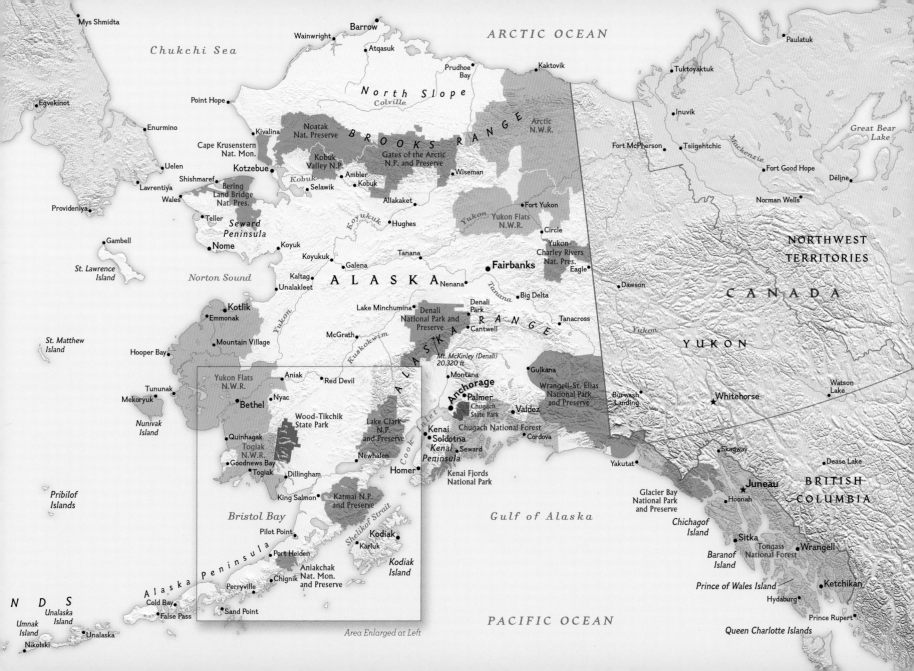

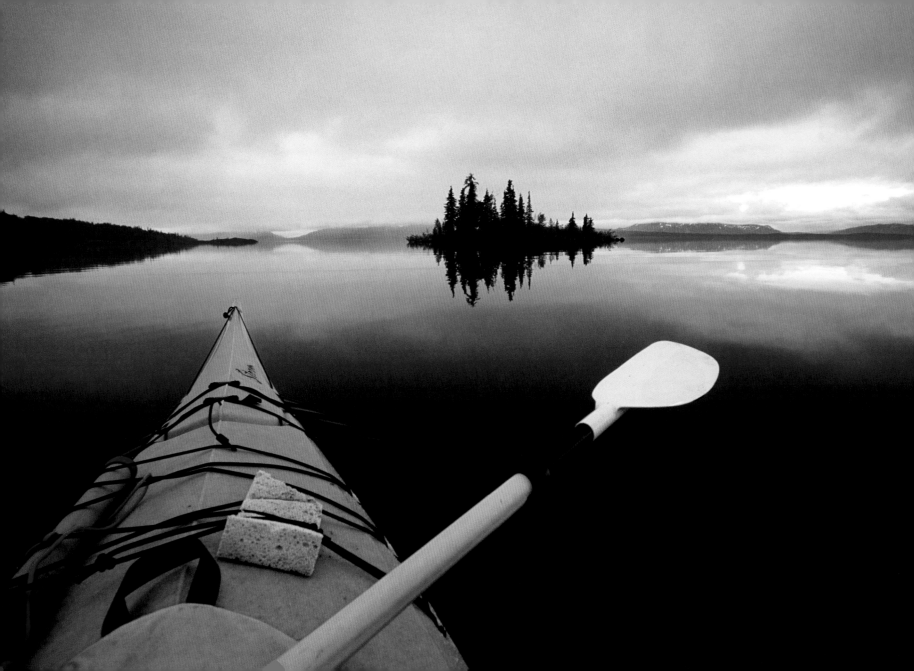

Photographer Michael Melford kayaks across the clear waters of Tikchik Lake in Wood-Tikchik State Park. At 1.6 million acres, it is the largest state park in the United States.

Preceding pages (6-9)
Humpback whales dive in Frederick Sound, having migrated to Alaska in the summer to feed before making the long journey back to the tropics to breed.

Low clouds hover over the point where the Nushagak River empties into Bristol Bay.

I'd like to say it was love at first sight, but I kind of knew, as we took our place in a long procession of cars, trucks, and travel trailers at that initial border crossing, that it wouldn't be easy. As the fumes and dust rose in a sun-soaked cloud, I waited, along with three college friends, for our turn to cross into Canada. Our car was loaded, so top-heavy that it looked as if it might topple over at any moment. I felt a faint apprehension hanging in the air, perhaps a premonition of just how tough Alaska would be. It was something I would fully realize after signing aboard a commercial fishing vessel despite having only seen the ocean a couple of times. Or after watching my friends spend the better part of summer in the dank recesses of an ancient cannery, a facility spawned at the dawning of the industrial revolution.

But Alaska is a place that you need to give its due. You must hang in for more than a few rounds to fully appreciate what gives it its bold, unrefined luster and its uncommon allure. A land as large and legendary as Alaska could easily take a lifetime to explore. Even its people—an eccentric merger of fundamentally different personalities—can take some time to get to know. Its extremes—not only its highest peaks and most secluded fjords but also its subtleties of light and form—take even longer. Yet it is the subtle and extreme nature of this place, a place I have come to love more than I ever imagined, that I wish to illustrate within these pages.

It is easy to fall into the trap of cliché when describing a land this extraordinary. Words often fail to do justice to the larger-than-life vistas that are our constant companion here in Alaska. Even years after I arrived, while working as a winter caretaker for the National Park Service, I would take in the unimaginably breathtaking array of glaciated peaks, bordered by vast stretches of virgin boreal forest, and be unable to convey even to myself the enormity of all I saw. I would be filled with an overriding surge of radiance and spirit—what poets

INTRODUCTION

refer to as a privileged moment—inspired by the raw beauty, the radiance, that engulfed me.

In lieu of words, I would hear music—the *1812 Overture*, to be precise—ringing in my head as I gazed about, clapping ski poles overhead like cymbals as the full force of this striking landscape and the power of this movement reached their crescendo in my mind. It is something I occasionally still hear when rendered expressionless by the sheer beauty, the magnificence, the spirit of this place that is our backyard.

It is a spirit that also resonated in the stories of those interviewed: the homesteaders, native leaders, scientists, and early politicians. And it was especially pervasive in the story of a young upstart guide and artist named Paul Tornow, who reminded me of what life was like when I arrived 26 years ago, a newcomer filled with all the promise this land still holds. "I was floored," he told me. "There was no way I was ever going home . . . I *was* home."

While any number of Alaska's regions might be held up as the crown jewel of our country's remaining wilderness areas, even among a land as unspoiled and varied as this, there are a few truly special places, the quintessential wilderness, the best of the best. For Alaska that very well might be the Bristol Bay region.

Larger than most states, it is a perfect symbol of everything that is unique about Alaska. It is a magnificent wilderness nearly untouched by human ambition and greed, one of our last remaining truly untamed ecosystems. Home to the greatest wild, and sustainable, salmon fishery on the entire planet, it is an area that, since commercial fishing began in the late 1800s, has consistently produced 35 percent of Alaska's salmon harvest. In 2008, 27 million sockeye salmon alone were caught. The Bristol Bay area is a land of sprawling acreage and our finest living conservator of wildlife, one that attracts photographers, bear viewers, and fishermen from around the world.

Yet Bristol Bay is also a land in transition. Today it faces the imminent threat of massive upheaval from open-pit mining and resource development at the headwaters of the bay. Until now the region has stood as a shining example of good management and stewardship. Yet we need not look far in time and distance to our neighbors in Oregon, California, and Washington—where commercial fishing has been severely curtailed and where the once mighty Columbia, at one time boasting salmon runs upwards of 16 million, now returns in the neighborhood of only 800,000, many of which are hatchery fish—to see what might happen here. Unfortunately, many North American salmon stocks today are maintained only in select pockets across the lower 48—like the last of the buffalo, a fading symbol of our once thriving wilderness.

But let this book not be about what might happen, but about what is. It is foremost a celebration of Alaska's extremes and its inaccessibility, all that sets it apart as something truly unique and special. For if all of Alaska was easy to reach, safe, tamed, and conquered, and all its wealth extracted, it would no longer be Alaska. This book then is a celebration of the wildness, the natural and human wonders, of this state and of the Bristol Bay basin, one of the last remaining American landscapes that has not been degraded, developed, or squandered.

Ultimately this is a work of hope—hope that this place will remain wild. It is a work whose purpose is to be a record not of what we may potentially lose but rather of what can still be saved.

SKA

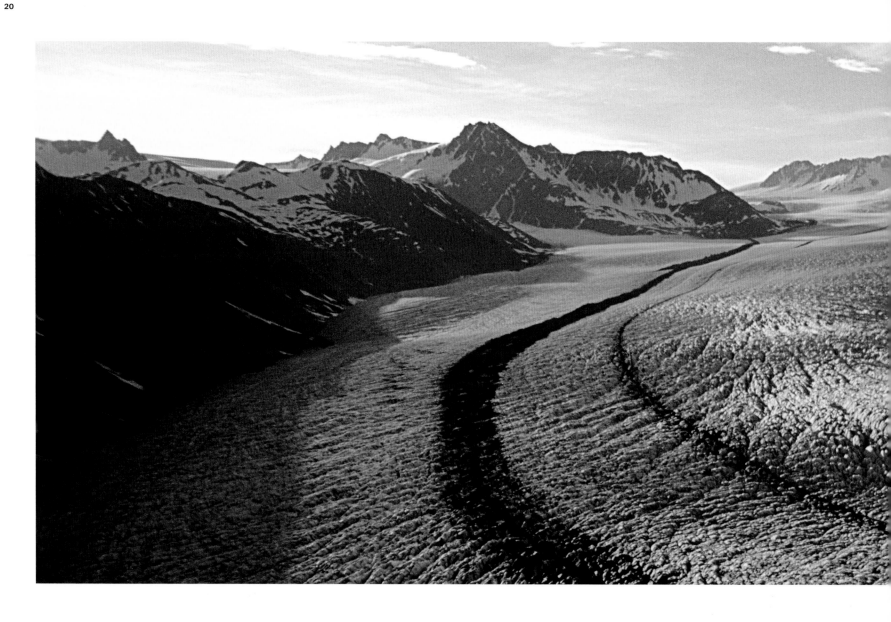

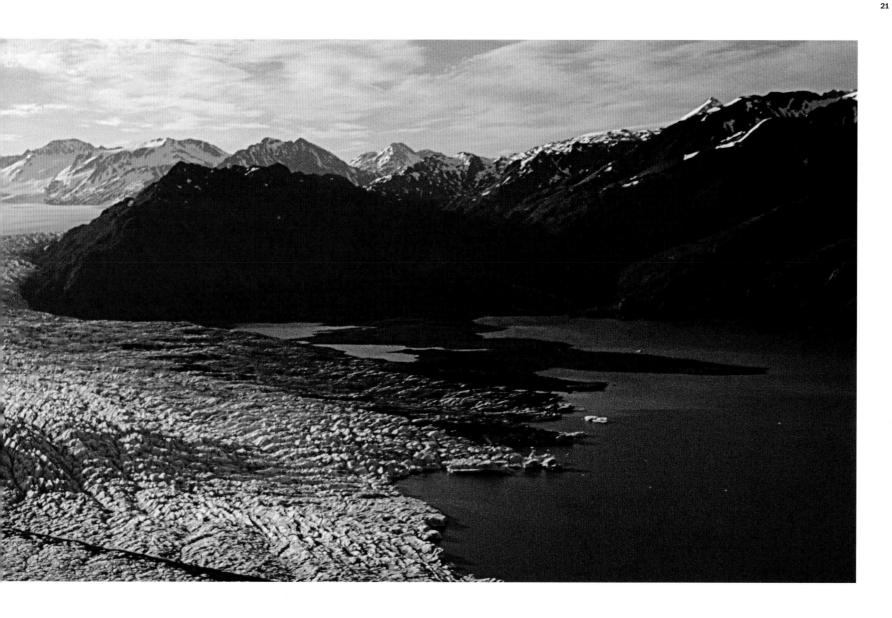

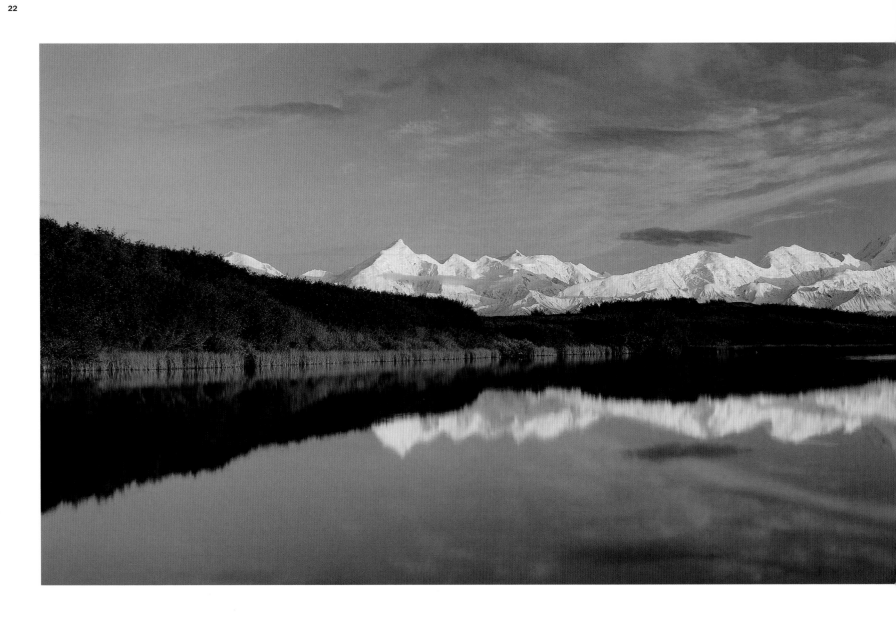

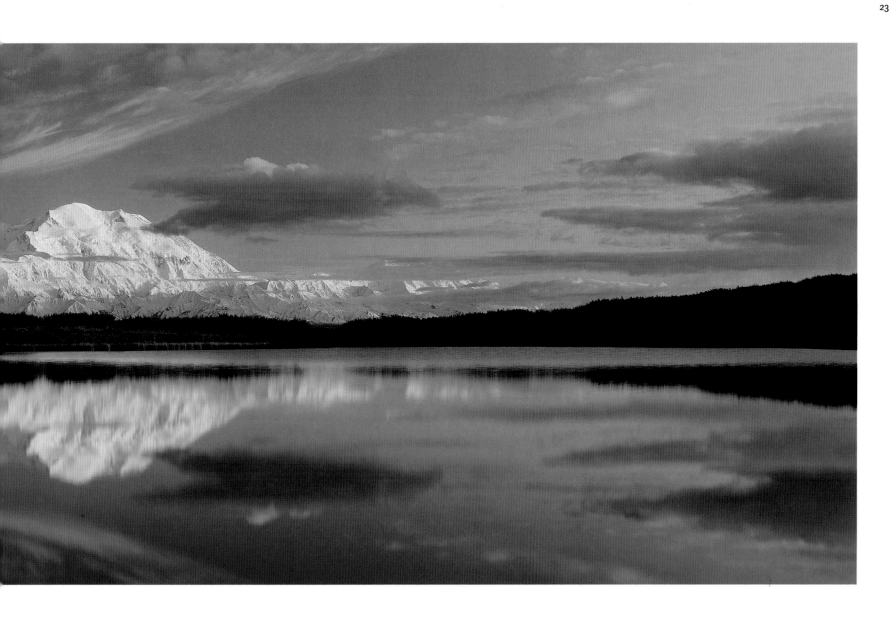

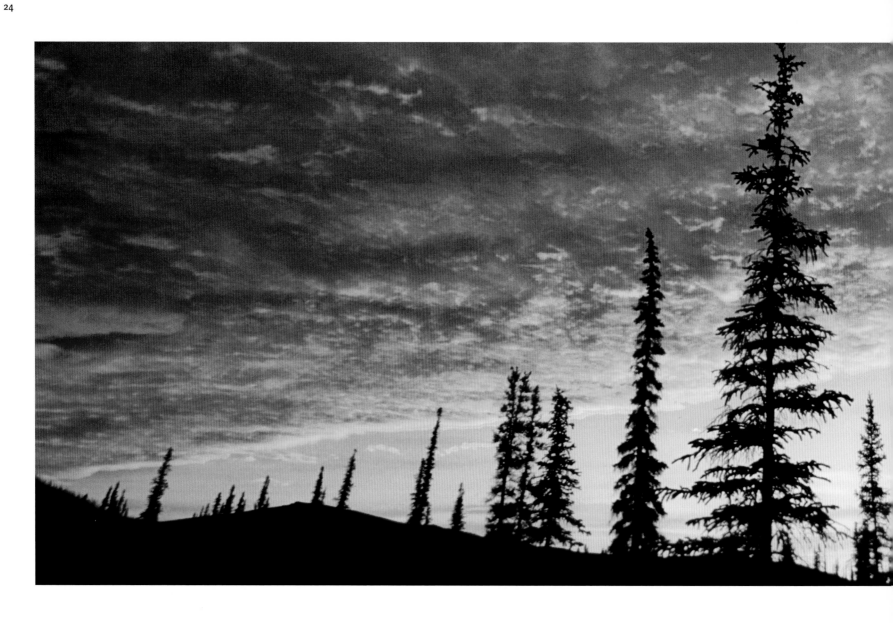

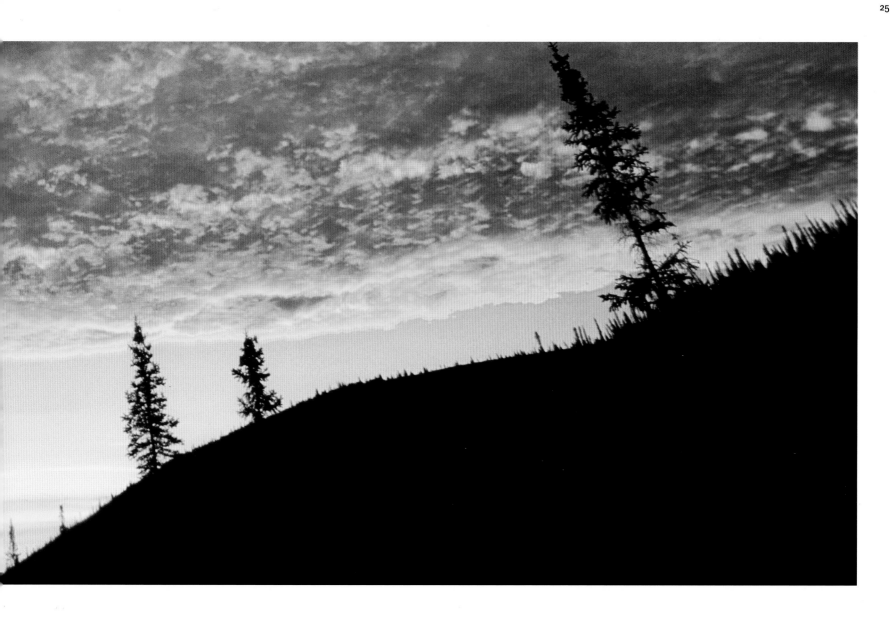

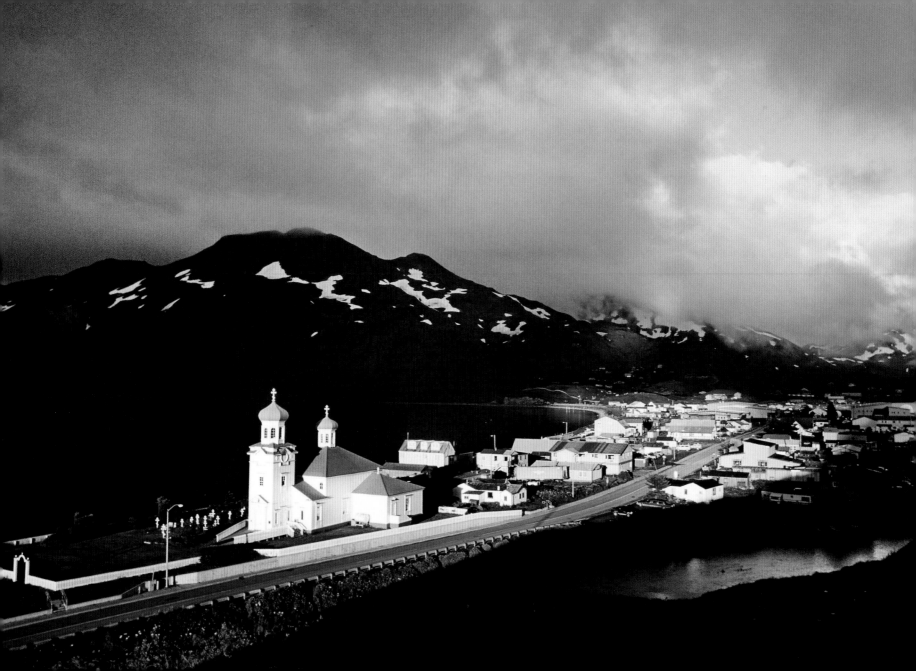

Clouds block out all but a strip of sunlight on Dutch Harbor in the Aleutian Islands. The port of Dutch Harbor brings in more seafood by volume than any other port in the United States.

Preceding pages (20-25)
The parallel stripes of dirt and debris that run down the middle of Bear Glacier—the largest of Kenai Fjords National Park's 38 glaciers—were formed when two glaciers merged.

The imposing image of Mount McKinley, North America's tallest mountain, is perfectly reflected in the crystal clear waters of Kettle Pond.

Land of extremes: At summer's peak, the Alaska sun begins to rise mere minutes after setting, whereas during winter, parts of the region plunge into nonstop darkness.

We arrived in the small coastal town of Seward, steered there after a chance meeting with a childhood friend who happened to work every summer at its cannery. The town was shrouded, as it often is, in a seemingly perpetual mist, a featureless curtain of fog, and a slow, penetrating rain. I could only sense something large lingering behind the clouds, smelling it in the sea breeze, something hanging heavy in the oyster-shell air that follows low tide. For four long days I walked in and around a perceived grandeur, disguised by the fog, sure that something awaited me but ignorant of just what it was.

Then, on my fifth day, I awoke to something incongruous. There was an unfamiliar brightness, and my tent, damp not with rain but with condensation, had suddenly transformed into a sweltering nylon oven. Dressing quickly, I emerged into a changed world. The enormous spruce trees were steaming and dripping dew in the face of this nearly forgotten bounty—the precious warmth of the sun.

Making my way to the edge of the campground, unable to believe it had actually stopped raining, I realized that something other than the weather had changed. It was impossible to pinpoint until I walked up a small knoll and reached the edge of the trees, where a completely new vision unfolded before me: a fresh portrait of Alaska, suddenly unveiled and far surpassing even my most romantic of notions.

And to think that for nearly a week I had walked blindly on the edge of it, around it, through it, completely oblivious to a world of such magnitude, eclipsed behind nothing but a thin mantle of low-lying clouds.

Now I looked down in wonder upon a village that appeared as though it were in peril of being swallowed by the sea. A tiny village tucked among mountains so spectacular it was as if they arose out of some unimaginable dream. Primordial, windswept mountains—white-faced, blue-veined, and cloud-rimmed.

LAY OF THE LAND

It was unbelievable. A revelation. All I could do was stand there and take the majesty of it in, feeling dwarfed by its immensity, yet at the same time feeling lucky to be a part of it.

Each year, for generations, newcomers have arrived in Alaska seeking a similar revelation. They range from visitors taking that once-in-a-lifetime vacation to adventurers planning on carving out a new life and even speculators hoping to strike it rich. With a landmass one-fifth the size of the lower forty-eight—two and a half times the size of Texas—Alaska is a wilderness jewel that at first glance appears limitless. Stretching across five distinct regions, from the fertile rain forests of the southeast to the sparse ethereal beauty of the North Slope, it is a land that has spurred the imagination and lofty dreams of many. Jack London's gritty tales of survival still lure travelers north. Author Jon Krakauer's account of his first trip to Alaska, in his book *Into the Wild,* describes a

journey "unfolding in a gauzy reverie of anticipation, propelled by an imperative that was beyond my ability to control or comprehend."

In its early days, newcomers to Alaska arrived solely by sea. This is a voyage many repeat today, usually in luxury, sailing the Inside Passage and exploring only a small portion of Alaska's 33,000 miles of coastline, a coastline longer than that of the contiguous 48 states combined. Although sailing might be one of the most picturesque ways to travel to Alaska, the advent of modern air traffic truly opened the state and made it readily accessible to anyone.

On any given day thousands fly into Anchorage International Airport, and yet many of the more intrepid—those with the time and inclination to discover for themselves a stark and still wild landscape—take to the road. For them there is nothing quite like the freedom of finally being under way, launching themselves

headlong into that great series of asphalt rivers whose currents first carry them north into Canada and then west into the unknown.

The road they take is the Alaska Highway. Although now largely paved, it was originally a dirt-and-gravel artery built hastily by soldiers during World War II. It was infamous for its clouds of swirling dust that would settle, when it rained, into potholes of thick gravy—booby traps just lying in wait for unsuspecting cars. By the time I reached this fabled byway, 25 years ago, everyone was heading to Alaska. They had been seduced by its song, swayed by its clergy of wanderers, hitchhikers, and free spirits. And there were all kinds, each headed for their own adventure, meeting up time and again as we crossed British Columbia and the Yukon.

Whether arriving by road or water, once in Alaska it is air travel that reigns supreme. It is the essential form of transportation in bush Alaska, and there are very few of us who don't enjoy taking off into the freedom of the clouds. Fortunately there are plenty of pilots in Alaska. In fact, in the 1940s, in her book *The Flying North,* Jean Potter called Alaskans "the flyingest people under the American flag." It is a moniker that still holds true, as demonstrated by the number of private planes in service as well as professional bush pilots plying their trade throughout the state. One of them is Rick Halford, a 20-year veteran of the state senate and onetime senate president, who for years led a dual life as bush pilot and politician. It was the flying, his life outdoors, that he credits for his tolerance and longevity in the world of politics. "I live by aerial photos and layout, a bird's-eye view of life. Without that, without my time spent in the air and in the wilderness," he asserts, "I don't know how I would have made it so long in the senate. Sometimes it's really difficult for me to imagine how other people, nonpilots, even view things. It will always be

my preferred mode of transportation, because on a small plane you see it all, how things were formed, how they are laid out, and most importantly the connection between them."

When you first arrive in Alaska, you notice that even the towns on the road system maintain a rugged uniqueness. Alaska is still a destination that beckons the adventurer, the individualist, and the free spirit. With large tracts of wilderness—65 percent of the acreage in the U.S. park system and 88 percent of the U.S. wildlife refuge system—and areas that are home to 15 species of whales and healthy populations of caribou, grizzlies, and moose, plus one of the last remaining strongholds of wild salmon, Alaska is still a place to behold. It is a land whose towering mountains and expansive vistas have inspired admiration and awe over the ages. As long ago as 1879, John Muir proclaimed in his *Travels in Alaska* that, as he arrived by ship, each succeeding view seemed more

and more beautiful—"the one we chanced to have before us, the most surprisingly beautiful of all"—and that never before had he been "embosomed in scenery so hopelessly beyond description."

The same raw beauty inspired homesteader Marge Mullen in 1947 to fly along with her husband, Frank, a World War II pilot, from Chicago to Alaska in a rickety old two-seater plane. Having seen a blurb in a Chicago paper offering land to veterans, the Mullens set off without even knowing where the Kenai Peninsula was. Later they walked a good portion of the way from Anchorage and staked out their homestead in what is now downtown Soldotna, today a settlement of nearly 4,000 in the heart of one of Alaska's premier recreation areas. Despite the endless work of raising kids, gathering food, and repairing the cabin, Marge Mullen would not trade it for anything. "We simply loved the outdoors," she explains, as if it was yesterday, "and were both truly taken by the wildness of the place."

Sixty years later, another new arrival would be just as taken by the wildness of Alaska. Making the drive alone from Minnesota at the age of 19, Paul Tornow came in search of the Alaska dream. A talented young artist, he now spends the bulk of his days outdoors, guiding fly fishers in summer before heading to interior Alaska each autumn for the hunting season. When he's not working in the wilds of Alaska, Tornow is there in spirit, his paintings always reflecting his time spent outdoors.

"That's because when I'm out in the wilderness," he explains, "there is always something that happens, something inexplicable." While it often is exciting—an adrenaline-stoked meeting with a grizzly or a 70-pound king salmon on the end of his fishing line—it can also be triggered by something simple, he says: "A bone sitting there on the beach or an eagle rising on the thermals. It's an encounter of some kind, an epiphany, something larger than yourself that you only experience in a place like this."

Many of us who have made the pilgrimage to Alaska know exactly what he means. Here we feel truly alive, aware of a natural world that we are all still a part of despite the intrusion of cell phones and Twitter. It is a greatness we are humbled by, an element that lives in the open sky, under the canopy of old-growth forest or beneath the gaze of these mighty cloud-rimmed peaks. Alaska is home to 30 distinct mountain ranges and includes North America's tallest peak: Mount McKinley, also known as Denali or "the Great One." At over 20,000 feet, it is an attraction that draws climbers and sightseers from around the world. It is Alaska's mountains, from the Wrangell-Saint Elias to the Brooks Range, that are also a common thread, a key element linking most of our stories and creating a blazing first impression. It doesn't matter whether it is John Muir in the 1800s, Marge Mullen in 1947, or Paul Tornow today. Alaska's mountains, these amazing geological miracles, are enough to inspire reverence in the most cynical and least spiritual among us.

Horned puffins spend most of their lives out on the ocean but return each year to the rocky cliffs of the coast to breed.

Opposite: Seagulls festoon the nesting grounds of the aptly named Gull Island, part of Kachemak Bay State Park. Kachemak was the first legislatively designated park in Alaska's now extensive state parks system.

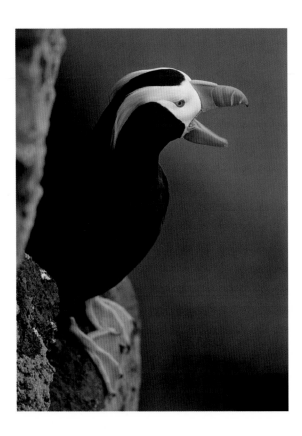

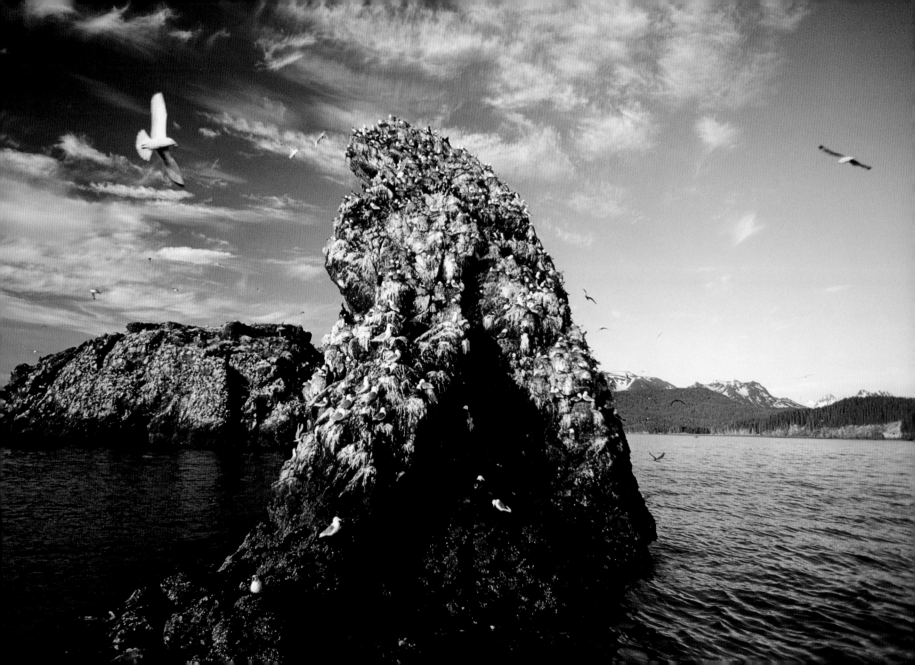

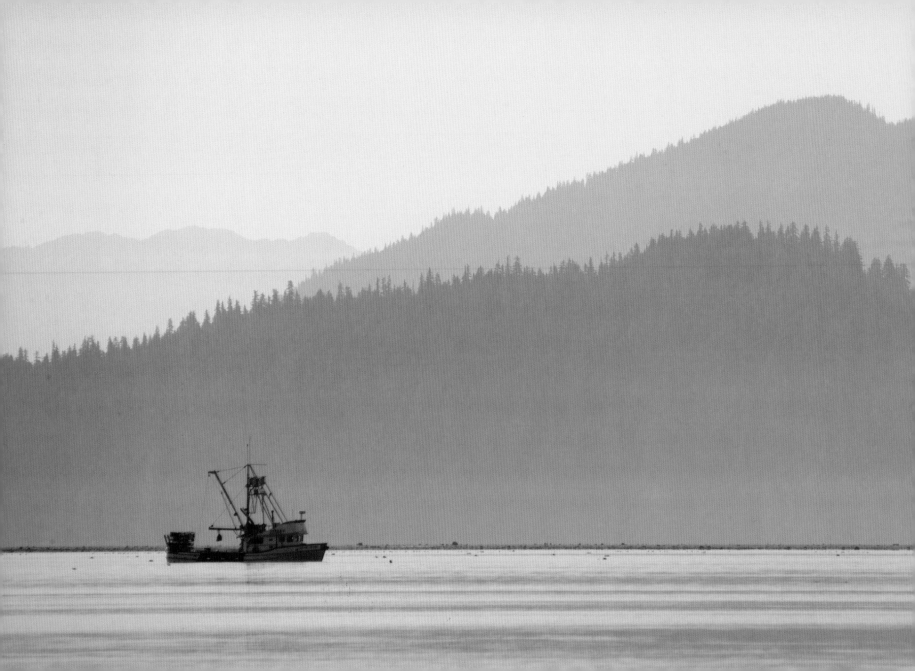

A fishing boat sails out from the port of Petersburg in Southeast Alaska amid the early morning light.

Following pages (36-39)
The brown bodies of countless walruses lounge on the shores of Round Island in the Walrus Islands State Game Sanctuary. Up to 10,000 males come here to rest and feed each summer.

A humpback whale breaches the waters off Yasha Island in Alaska's Inside Passage. Male humpbacks produce intricate underwater songs that last for several minutes.

The Igushik River twists and turns like a roller coaster through the center of the Togiak National Wildlife Refuge. The river carries water from Amanka Lake down into Bristol Bay.

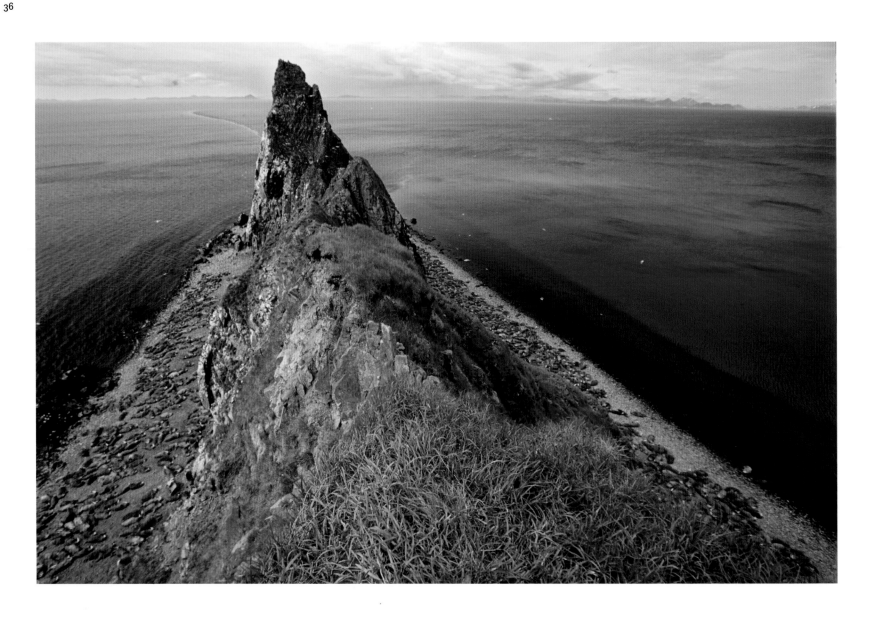

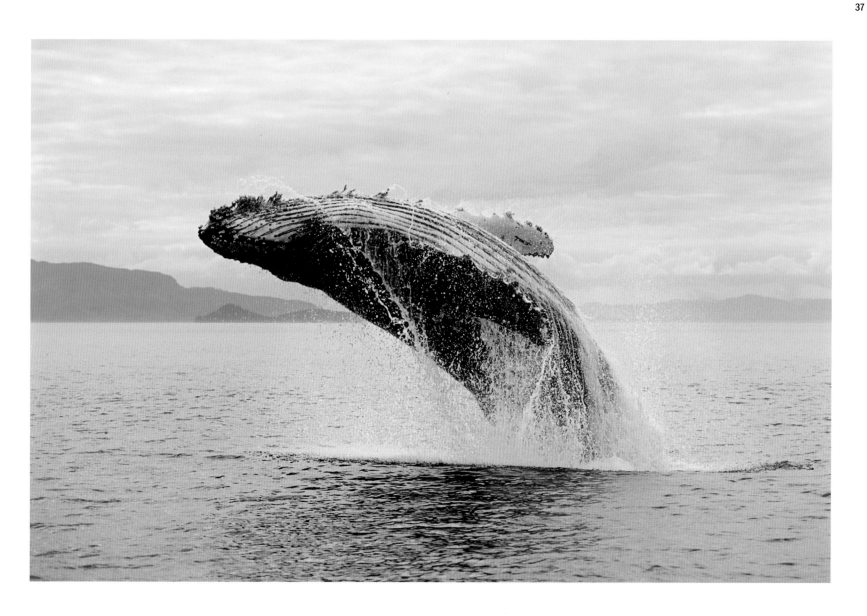

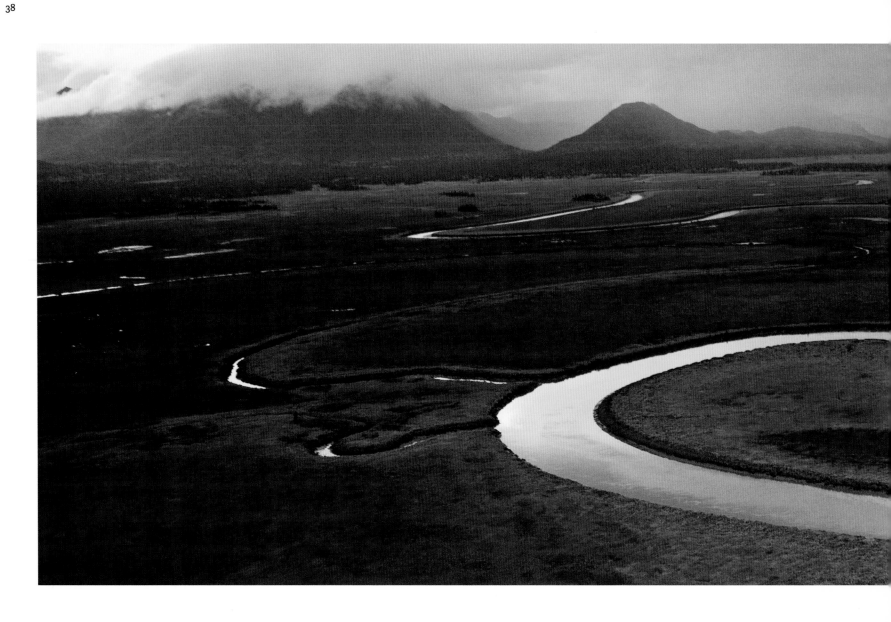

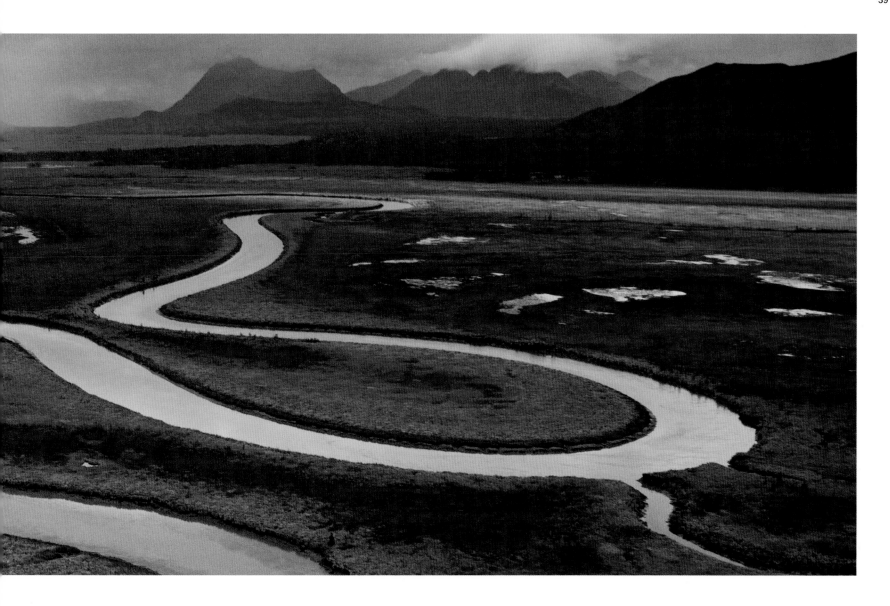

Foxtails blow in the summer breeze inside
Denali National Park. Denali—"The Great One"
in the Athabaskan language—is the native name
for Mount McKinley.

Opposite: The stunning colors of an Alaskan
autumn are seen off the side of Denali Highway,
a sparsely traveled gravel road with a recom-
mended speed limit of 30 miles an hour.

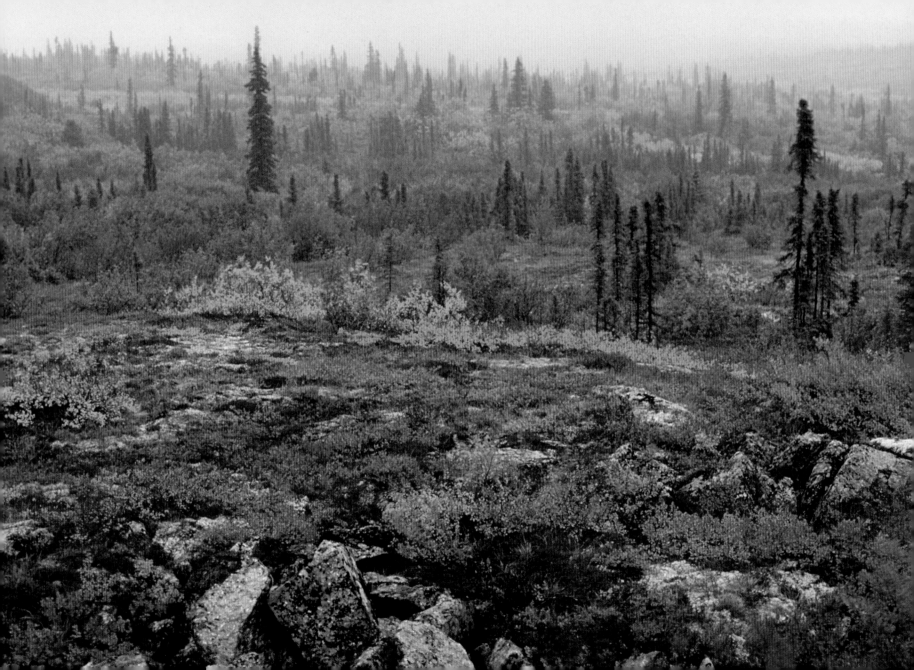

A flurry of kittiwakes blur the view above Hartney Bay. This species of gull nests exclusively on cliffs and can be found all along Alaska's coast.

Following pages (44-47)
A female moose is caught by surprise while wading in Harding Lake. The Alaskan moose *(Alces alces gigas)* is the largest type of deer on the planet.

Untouched wilderness is everywhere in Alaska. Spruce trees on Kodiak Island are almost entirely covered in soft moss.

Once populous, Steller sea lions were placed on the endangered species list in 1990. Overfishing is one possible cause for their decline.

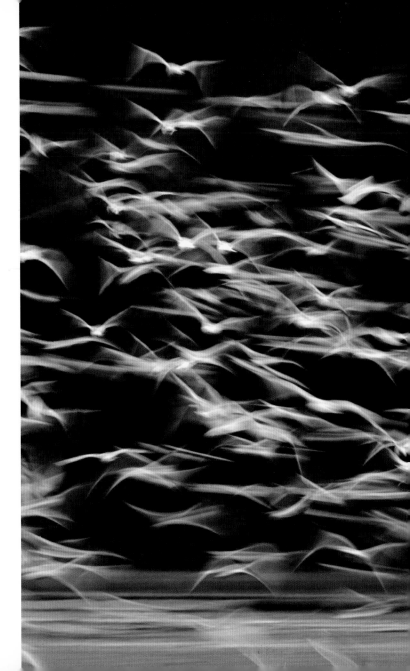

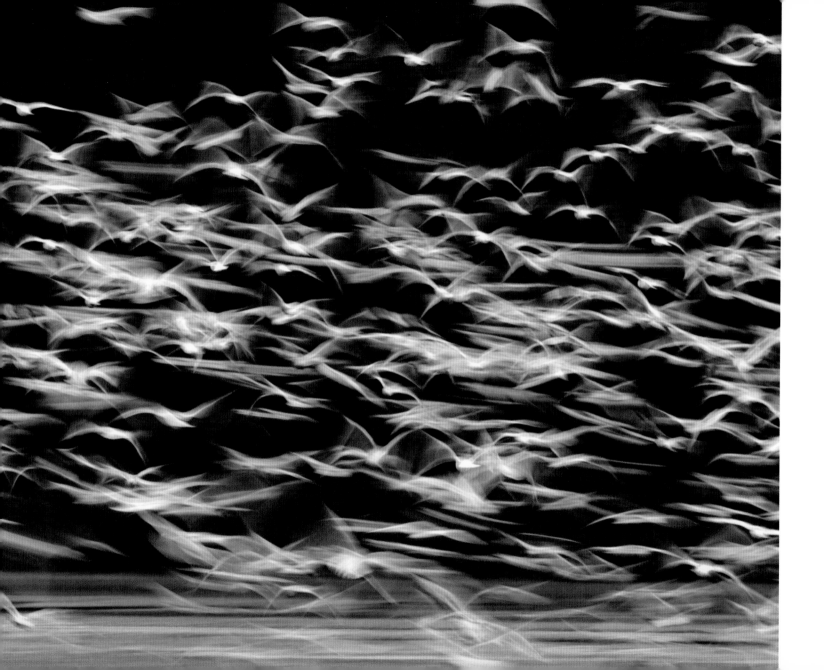

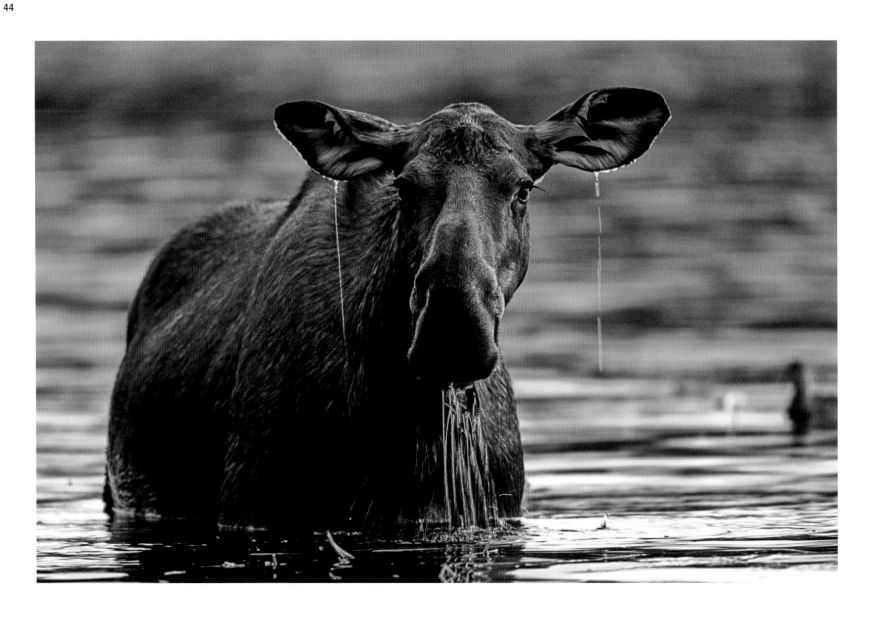

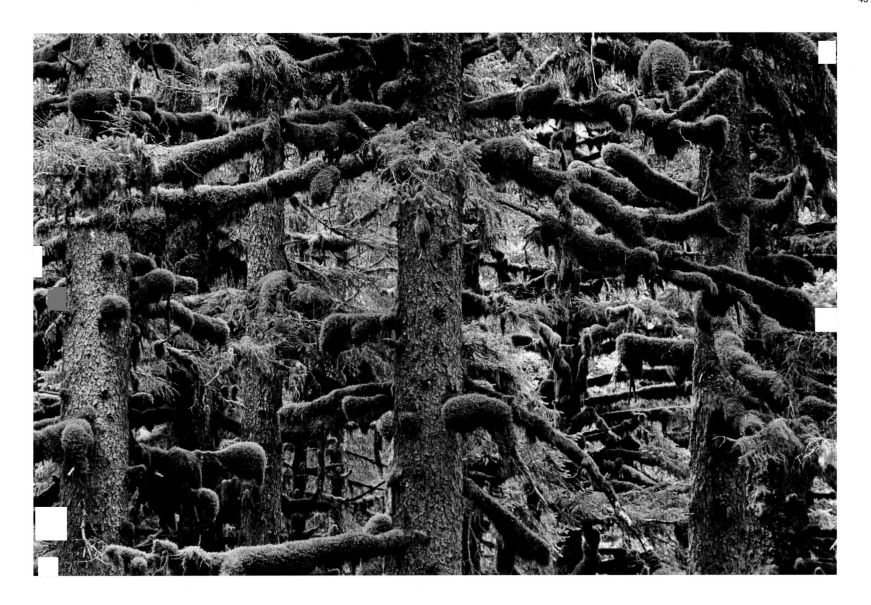

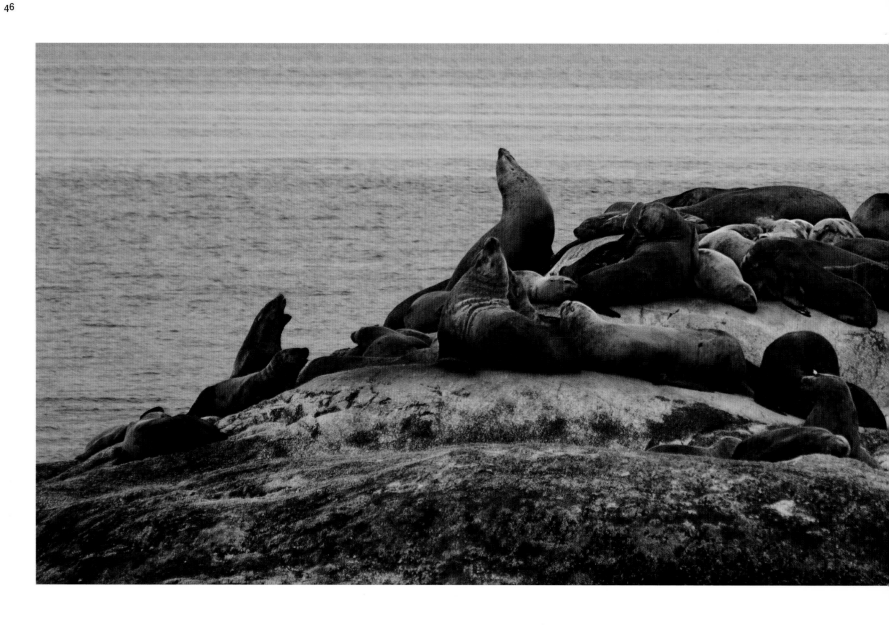

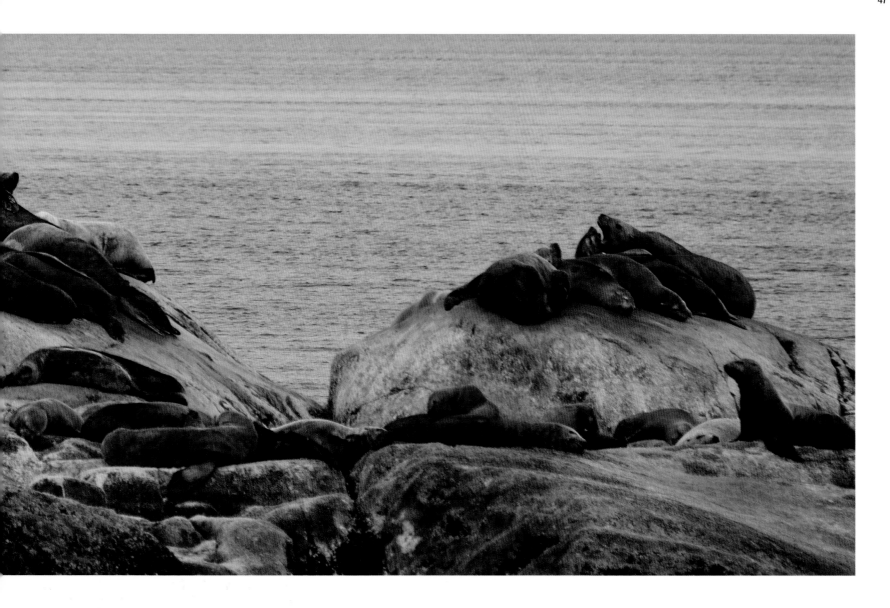

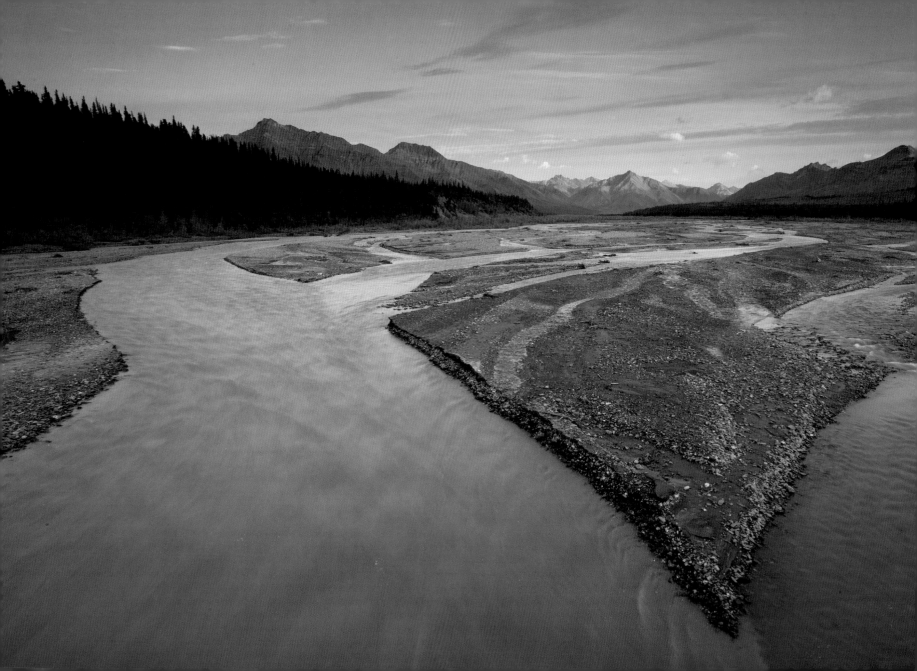

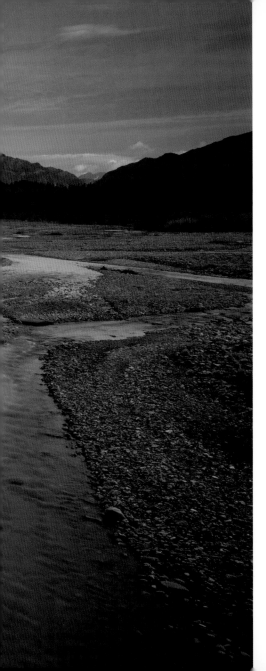

Teklanika River snakes through the raw wilds of Denali National Park. Alaska's many parks and refuges are some of the last holdouts of pristine nature left in the United States.

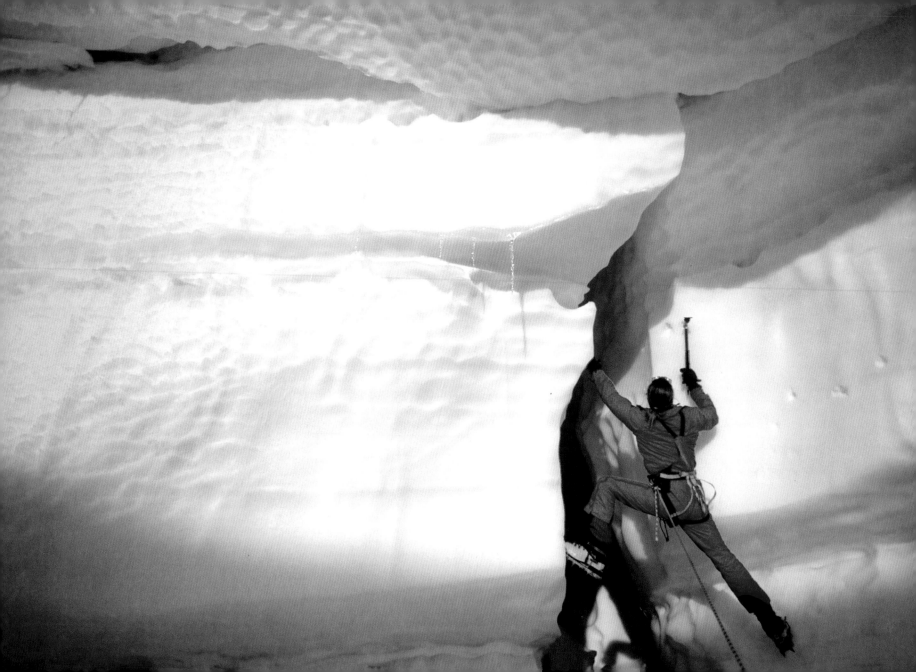

An ice climber finds his footing on Ruth Glacier in Denali National Park. Alaska draws many adventurers who want to tackle its challenges and experience its wonders.

Alaska is a land of extremes, as pure and simple as night and day. And daylight is something Alaskans never take for granted. It is a rare commodity, especially after a long winter, something we thirst after and soak up. We revel in the warmth of mid-morning, watching as the sun slowly washes away the last vestiges of lingering clouds and reveals for us the masterpiece of surrounding forest, a portrait dabbed in the full spectrum of greens and browns and cast against the tattered backdrop of jagged, snow-capped peaks. We look forward to its soft hues all winter, waiting for the endless days of summer with their long hikes, midnight softball tournaments, and all-night bull sessions around the campfire. Summer also brings with it a year's accumulation of jobs, leaving barely a moment to plant and paint. For some—commercial fishermen and guides—it is time to gear up and earn a year's wages in only a matter of months. It is a mad, exuberant dash, an onslaught of labor and play, and an often feeble attempt to fit it all in, because, as Alaskans like to say, "there will be time to sleep next fall."

While our summers are busy and life bountiful, it takes a certain constitution to stick it out through winter. To not despair but to rejoice or to at least graciously accept the traces of snow, "termination dust," when they first settle upon the mountainsides. You know it won't be long until the water dripping off the eaves thickens into crystal stalactites and dead leaves begin to swirl with the first snowflakes before settling upon the frozen ground. As the night grows progressively longer—at solstice only six hours of daylight are bequeathed to the villages of Southeast Alaska and one long winter evening descends upon those farther north—we know we must not succumb to its torpor.

With temperatures that can fluctuate 80° in a single day and temperatures in the interior region that often hover well below zero for weeks on end, it would be easy to hunker down indoors, tying flies or watching television. But to keep cabin fever—now called seasonal affective disorder, or SAD—at bay, we must take stock in the

LAND OF EXTREMES

extreme and embrace our rapid descent into winter, eventually welcoming its slow, lingering pace and quiet eloquence. While some resort to light therapy or other New Age remedies, for many of us the real cure is to regularly exit the comfort of our home fires and armor ourselves in layers of polypropylene, polar fleece, and fur. Here in south-central Alaska, it will usually only take a little prodding to convince a friend to shovel snow and chop ice out of the bottom of his drift boat and head out for a late-season float. Farther north they will have already strapped on skis, saddled a snow machine, or lined up a dog team and taken to the frozen rivers, suddenly transforming them into sweeping byways that link villages previously only connected by air.

Perhaps what drives many of us out is the sense of urgency, of adventure, that comes to life in extreme weather, even in a place we know well. But there is also solitude. On the rivers that stay open, the water has dropped significantly. With the boats of summer long gone, it is so quiet you can hear the brush of an eagle's wings as they sweep the horizon, darkly silhouetted against the muted light of midday. And there is not another soul within view. Even the most heated war zones, where hordes of sportfishermen regularly gather for "combat fishing" during the summer battle for sockeye salmon, have been relinquished to the true spirit of the river. The only footprints encased in the frozen ground now are the few wayward paw prints of restless bears who, like us late-season drift boaters, don't know any better and have left the comfort of their dens for a day on the river.

It is not just the climate that makes Alaska a land of extremes. Alaska is also extreme in size, age, and attitude. Spanning 57° 34' of longitude, and taking several full days to cross by car, Alaska looms large by anyone's standards. At the same time, with a population well under a million, it can feel very small. It is not uncommon to run into someone you know in the most

out-of-the-way location, from an interior village to a port on the Aleutian chain or just about any far-flung ferry or airport terminal around the state. Alaska is small-town small, where you likely know your mayor and just about anyone can still set up an appointment with the governor.

Alaska is also a vivid contrast of the old and new. We've only been a state for a little more than 50 years. Although occupied by a small number of Russians in the mid-1700s, Alaska did not see its first real influx of white settlers until nearly 40 years after its purchase by the United States in 1867, when the salmon canning industry began to boom and the Klondike gold rush occurred. With steady population growth not occurring until the 1960s and '70s—and thus with very little but the most recent architecture filling our streets—Alaska at first glance might appear relatively new, but that would be a misperception. Alaska has been home to various native peoples for at least 11,000 years, with

the Athabaskans of the interior region probably being the first to cross what was then a land bridge from Siberia. Alaska continues to be the home of various thriving ancient native cultures, from the Tlingit and Haida of Southeast, to the Yupik and Inupiat of our western and northern reaches, to the seafaring Aleuts, who have occupied the windswept Aleutian Islands for generations.

We are also ancient geologically, a product of the Ice Age. Look no farther than our estimated 100,000 glaciers, many of which still stretch into vast icefields like the Harding, Sargent, Bagley, and Juneau fields. These great expanses of the frozen past, still palmed within the heart of immense mountain ranges, offer a glimpse of what much of Alaska might have looked like tens of thousands of years ago. From our interior glaciers to those that so many of us regularly visit via cruise ship or private vessel, it is easy to gaze upon them in wonder. We are awed by the sheer spectacle, watching

intently as they calve, those that extend seaside literally exploding into the ocean, depositing with their great might ancient minerals and churning a wake often capable of capsizing even a moderately sized boat. More than merely an attraction, they are an extraordinary force that continues to mold our fjords, carve our river valleys, and sculpt our peaks.

Along with Alaska's immeasurable beauty, it is partly these dichotomies, these spikes in temperature and time, that originally attract so many of us. Some, like me, come for a summer and stay for a lifetime. Others leave after a short period, only to return for good when they realize what they are missing.

They say you don't choose Alaska, it chooses you. Unlike other places, it becomes a part of who you are and helps define you. Politicians advertise themselves as a 20-year, 40-year, or lifelong Alaskan. The average citizen finds a way to fit it into conversation, wearing it as a badge of honor. We take pride in living in Alaska and like the fact that we can still walk out our doors and be lost deep in the wilderness—real wilderness—where even within city limits we might meet up with a bear or moose. We revel in the state's abundance, easily filling our freezers each year with halibut, salmon, berries, and game. We marvel at all we see, from rafts of otters and sea lion rookeries to great formations of migrating birds, from Dall's porpoises playing in our wakes to herds of caribou, the nomads of the tundra, crossing wide, boundless plains.

While only a few of us have come solely for the purpose of living beyond the confines of society, many of us have tried it, at least for a little while; perhaps as winter caretakers or commercial fishermen in places where we are allowed to lose track of the man-made. We weigh change only by the direction of the wind or course of the clouds, park vessels or set gear by feel, and live in rhythm with nature, every action dictated by tides and weather patterns.

We Alaskans on the whole are a stubborn and independent lot. We love long races and wild sports. Often our heroes are individuals: cross-country trekkers, mountain climbers, or mushers who win the Iditarod, our unofficial state sport, the 1,150-mile dogsled race run each year from Anchorage to Nome.

While the majority of us declare ourselves nonpartisan, we regularly stack a conservative political deck, although with more than an occasional wild card thrown in. We are a people who relish our rich natural resources, love the outdoors, and claim allegiance to the wild. But at the same time, we are clearly a resource-extraction state, dependent almost entirely on oil taxes and royalties to run our state government.

Many of us hold a hard libertarian view, decrying the "lockup" of federal land, though at the same time taking full advantage of the nearly unfettered access it provides for hunting, fishing, and hiking. While we harbor a deep-seated distrust of "big" government and openly object to its intrusive reach, we receive more federal money than most states, pay no state income tax, and receive a yearly dividend from the government based on the savings and investments made with our oil revenue. Driving down the street we are as likely to see bumper stickers that proclaim "Salmon Love Wetlands" as ones that promote "Less Trees and More Jobs." It is a strange, extreme brew, a disparate whole that produces and attracts eccentrics, where you are likely to meet anyone from a tree-hugging hunter to a roughneck hippie, though almost always with a live-and-let-live attitude.

A part of our extreme independent nature may be derived from a recent history that includes tales of individual gold seekers, loggers, and fishermen who made their way here in the past century to find their fortune. They were men and women who loved the outdoors and for whom hard work and

Imposing granite spires, known as the Arrigetch Peaks, ring glacial cirques in northern Alaska. Arrigetch means "fingers of the outstretched hand" in the Inupiat language.

long hours were a virtue to be held in high esteem. Today there is still an adherence to these values together with a longing for the days when an individual with a gold pan or an axe could come into the country and manage to make his way. Unfortunately, in the 21st century opportunities such as these are much more difficult to come by. Today we are more likely to see a conglomerate arriving by private jet, often importing a string of employees who otherwise might not have come.

Yet it says something about Alaska that someone like the young guide Paul Tornow can arrive here and still be taken by its wildness. That his first impression can sound so surprisingly like the homesteader Marge Mullen's, even though hers is tempered by 60 years of change: a town sprouting up around her homestead, a tourism and oil boom, and massive new resource development. It is a tribute to all Alaska still is, though also an indication of just how difficult change is to track over the generations.

We can only hope that in the future we will take stock in what we have, because for every person like Mullen and Tornow, there are scores of others who don't see the intrinsic riches but only a way to get rich themselves. The time has come for Alaskans, and all citizens of the world, to ask ourselves some important questions about our few remaining wild places. As there are less and less of them, don't those that are left become more valuable?

As more of the world sinks beneath a veil of concrete and steel, don't our still intact ecosystems, these oases of solitude and sheer beauty, increase in pricelessness? The time has come to examine just what exactly progress is and ask ourselves, At what point do we lose more than we gain? These are questions much of the country has already answered, but they are questions lingering in Alaska's near future. And they are questions that may be no more timely, no more immediate, than in Bristol Bay, Alaska's hidden gem.

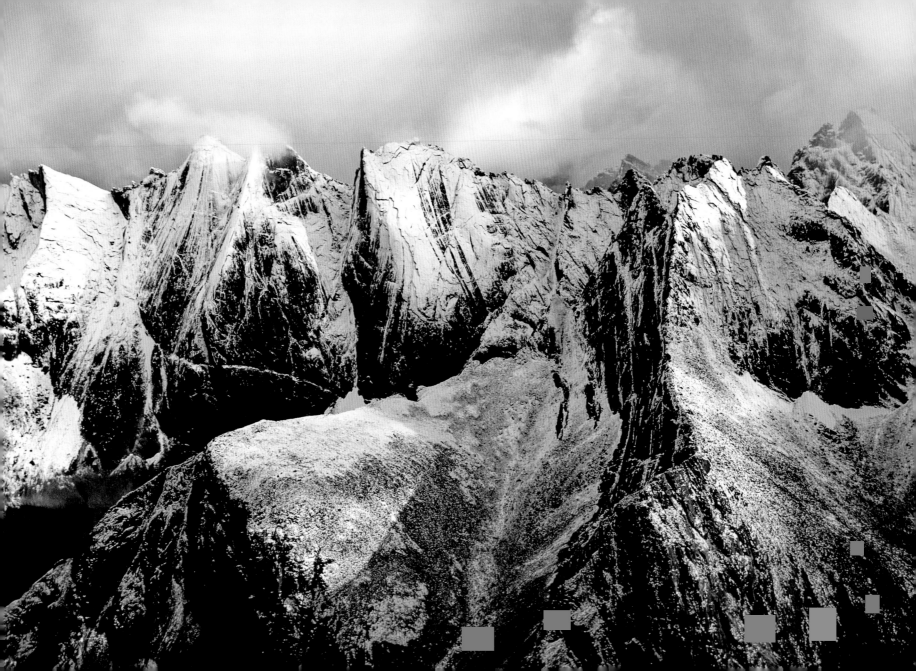

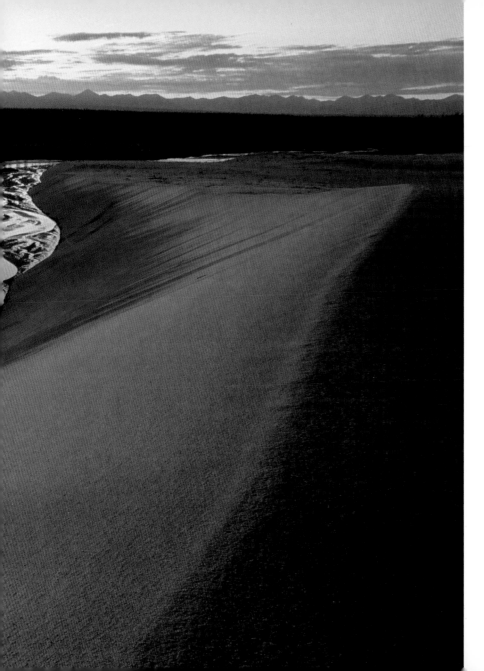

The sun sets on northwest Alaska's Great Kobuk Sand Dunes, through which humans passed during the last ice age, 10,000 years ago, according to artifacts found here.

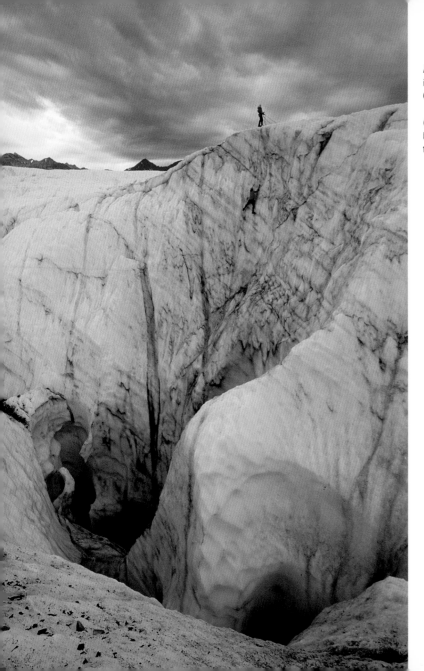

A pair of explorers climb the face of Root Glacier in Wrangell-Saint Elias National Park near the Canadian border.

Opposite: Tourists on a canoe tour of Mendenhall Lake get an up close and personal look at the jagged face of Mendenhall Glacier.

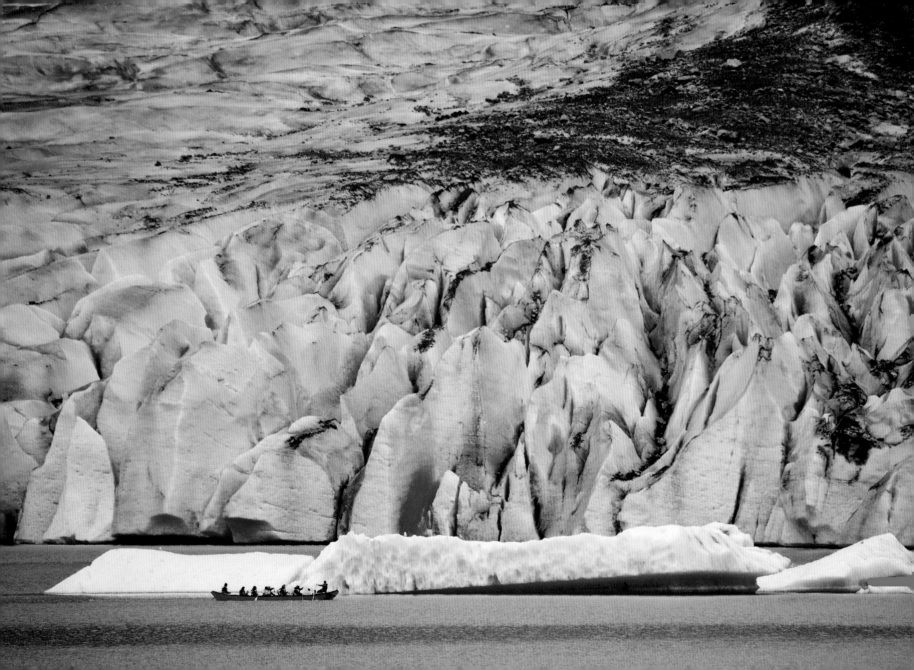

The splash of a large ice chunk falling from Johns Hopkins Glacier shatters the quiet of the frozen sea. This process, called calving, is how many icebergs are formed.

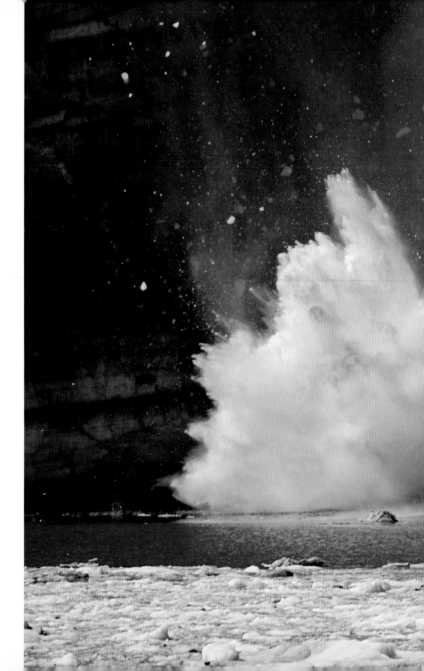

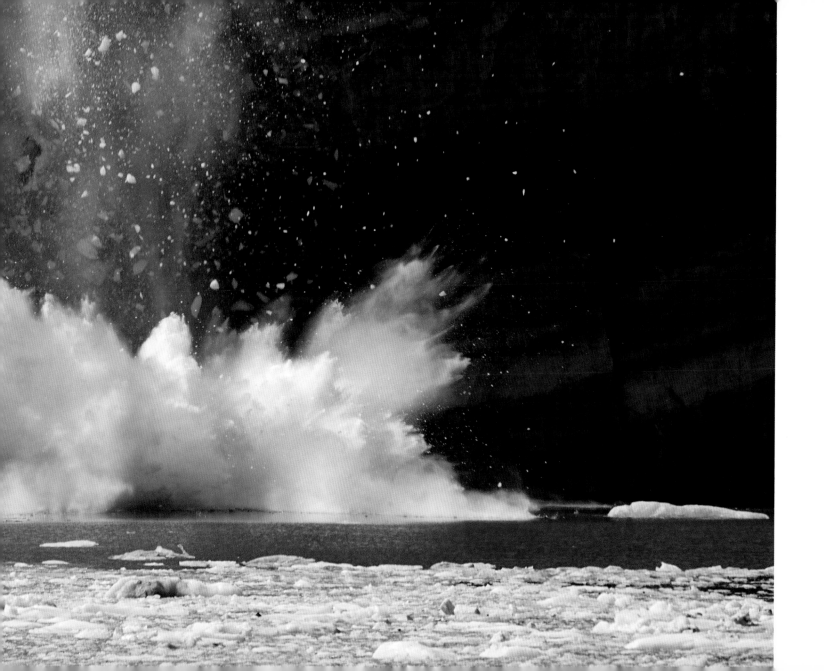

During courtship, crested auklets such as these display a curved crest of black feathers on their head and rub a citrus-smelling scent on their potential mates.

Opposite: Rocks jut out of the Bering Land Bridge during a full moon. Humans most likely populated North America by crossing during the last ice age, when the bridge connected to Siberia.

Following pages (66-67)
Cape Krusenstern and the Chukchi Sea as seen from the window of a Cessna plane. Small aircraft are an essential method of viewing much of Alaska's isolated wilderness.

A starfish is abandoned by the low tide of Sitkoh Bay in Tongass National Forest.

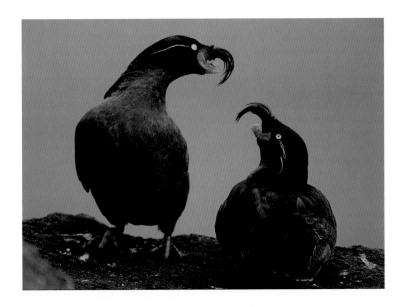

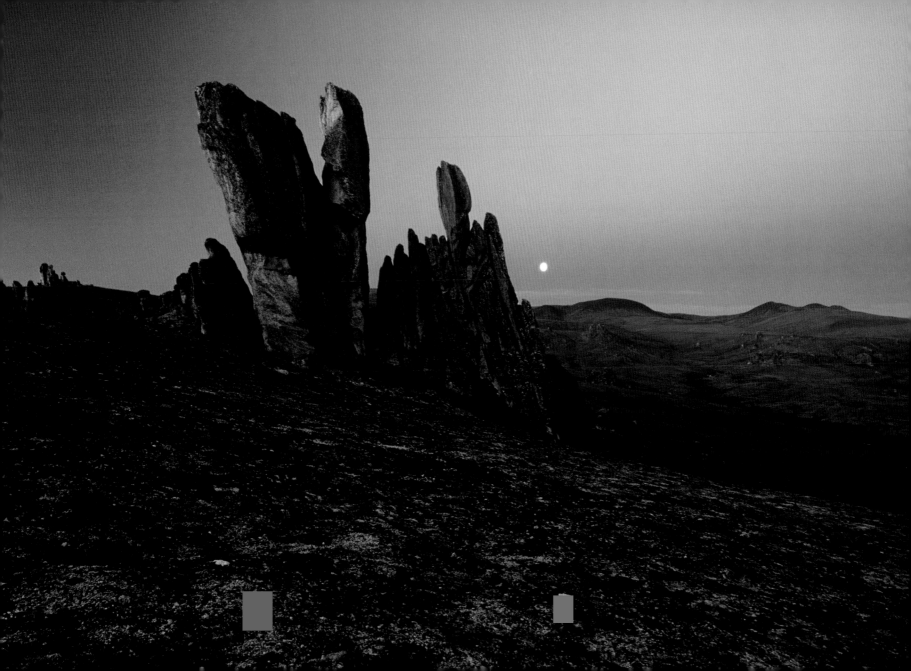

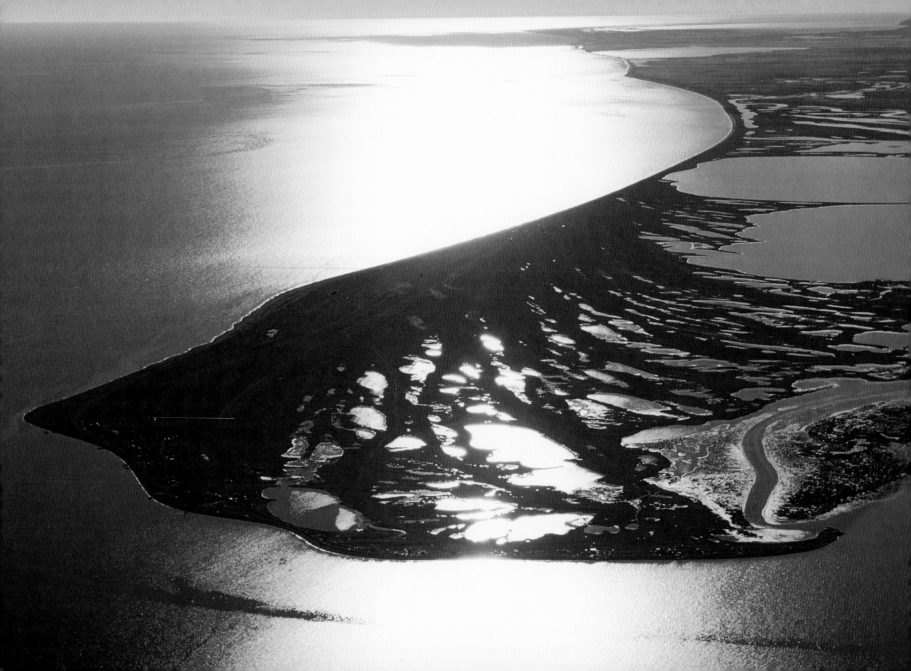

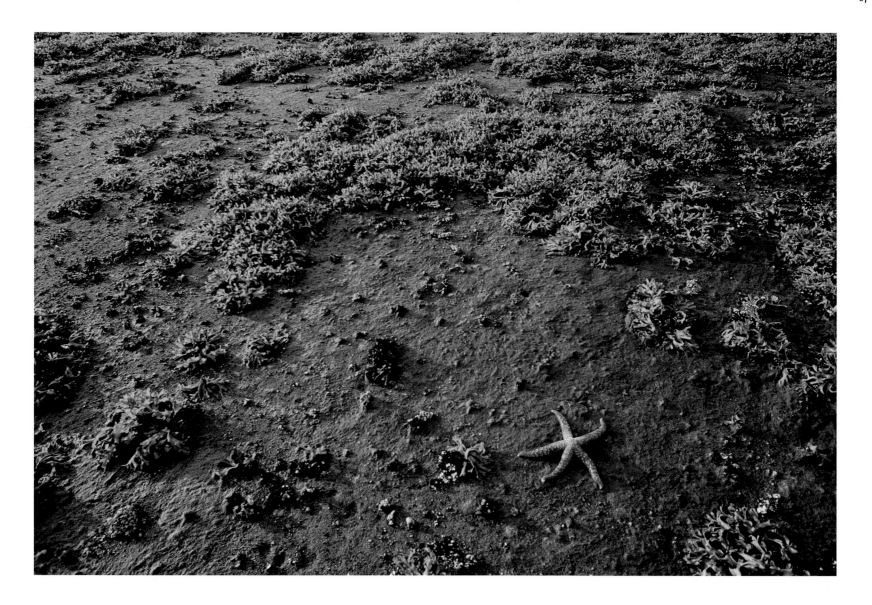

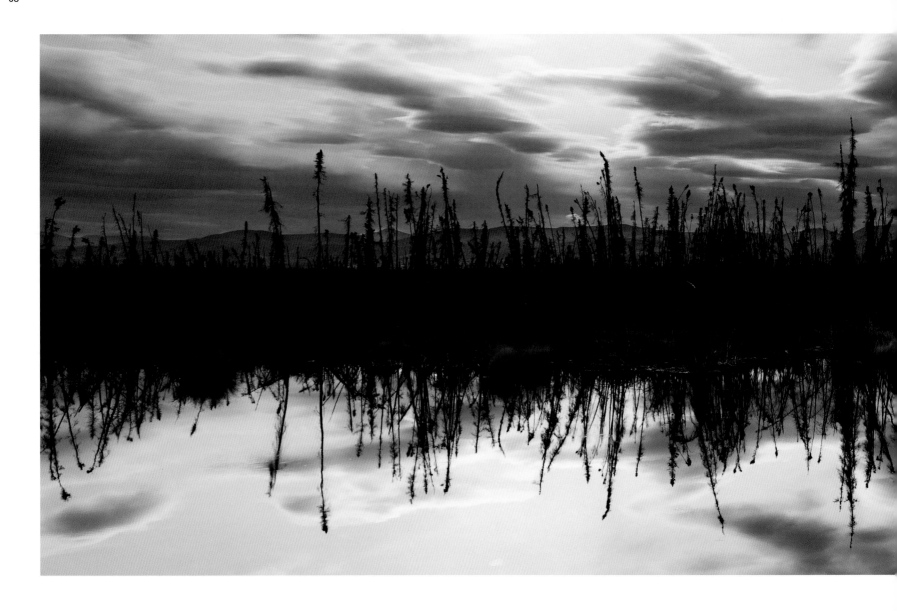

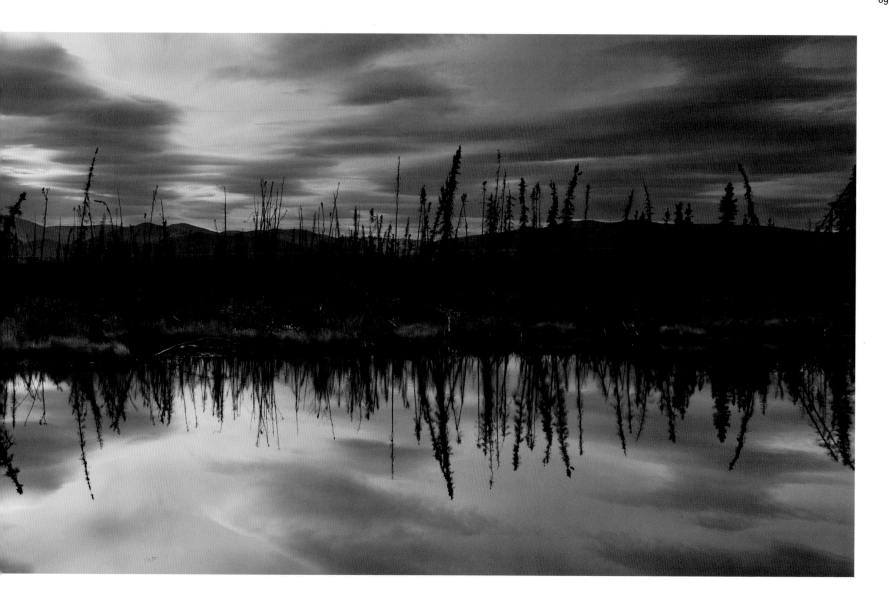

Veins of evergreens stand out among the yellow fall leaves of balsam poplars, which are the most widespread broad-leaved trees in Alaska.

Preceding pages (68-69)
Grass is reflected in a creek alongside the Steese Highway, which runs through part of central Alaska. The highway was built in the late 19th century to service mining operations in the interior.

Following pages (72-73)
Wilderness preserves—such as Gates of the Arctic, where these caribou were spotted— are lands vital to the survival of migrating species of fish, fowl, and mammal.

Migratory birds, such as this sandhill crane, take temporary breaks from their long flights to the far north and south to rest in Creamer's Field Migratory Waterfowl Refuge.

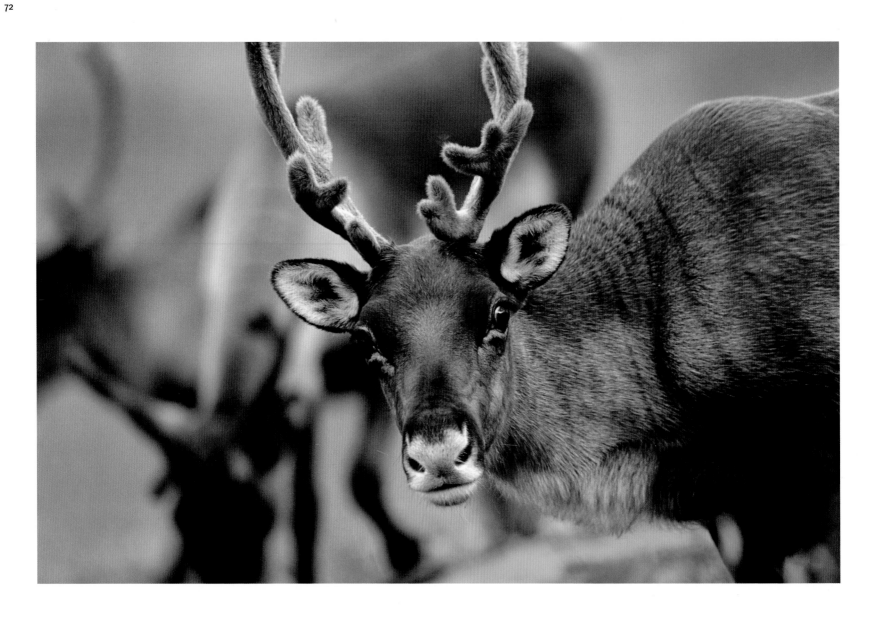

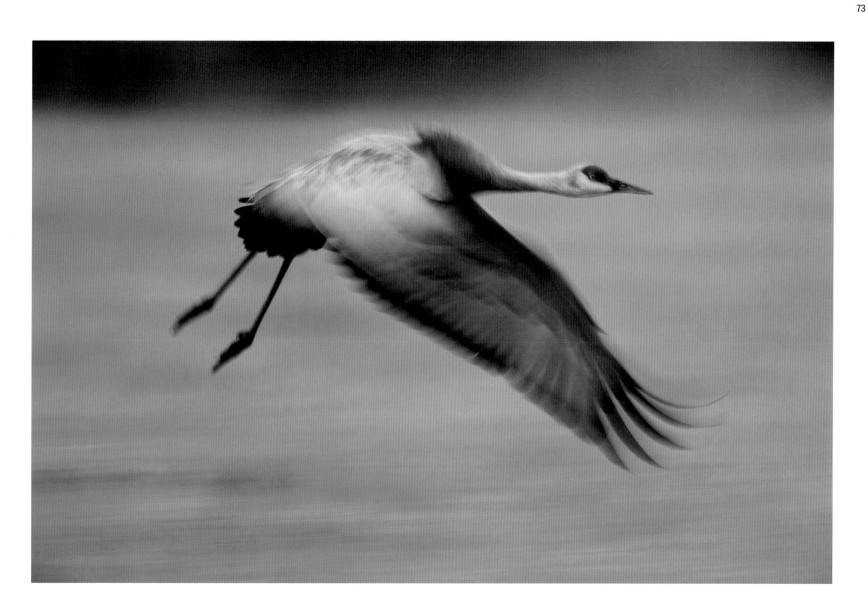

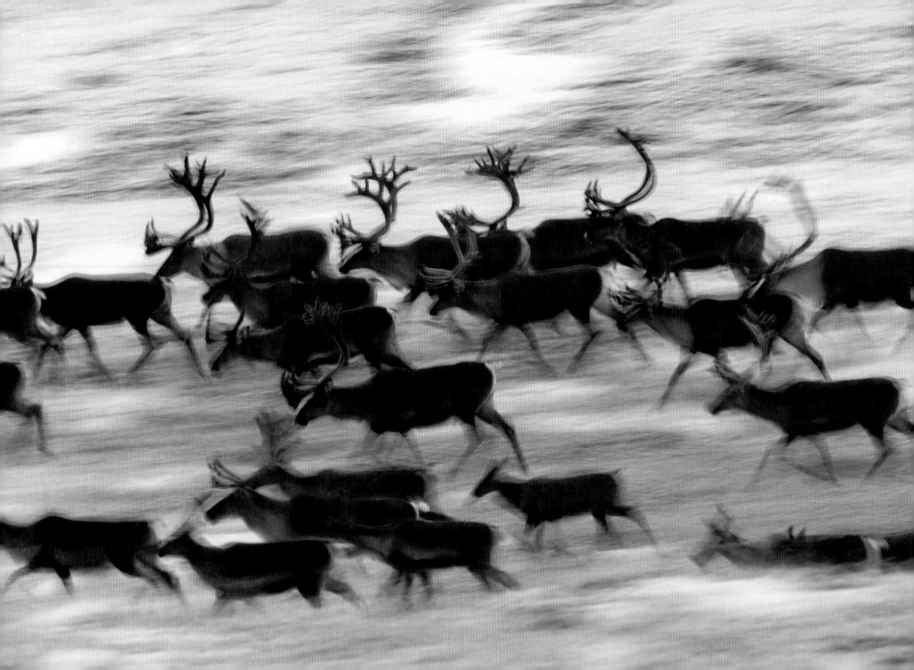

A mountain goat gazes out from a cliff in Glacier Bay National Park. Mountain goats spend most of their time above the tree line, avoiding predators on the rocky cliffs.

Opposite: Certain herds of caribou will migrate more than 3,000 miles a year, farther than any other terrestrial mammals.

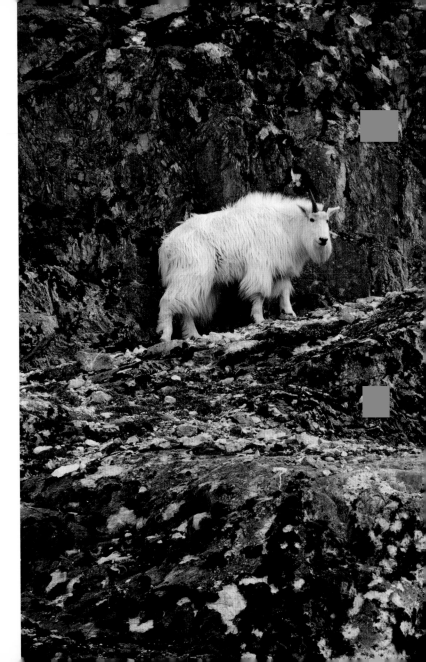

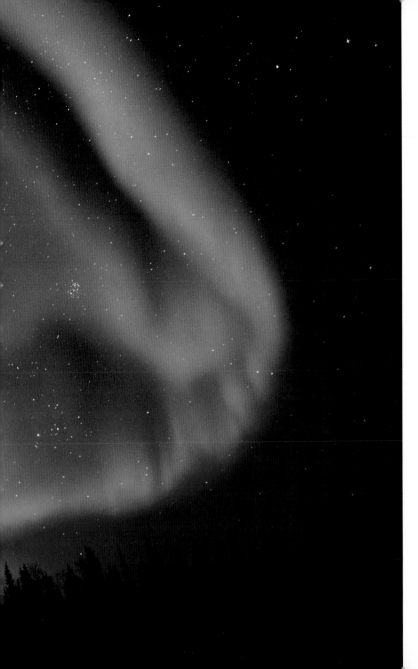

The eerily majestic northern lights, or aurora borealis, blaze above Twelvemile Summit on the Steese Highway.

Following pages (78-79)
Setting and rising within minutes, the sun frames Kijik Mountain in stunning orange light as seen from Port Alsworth.

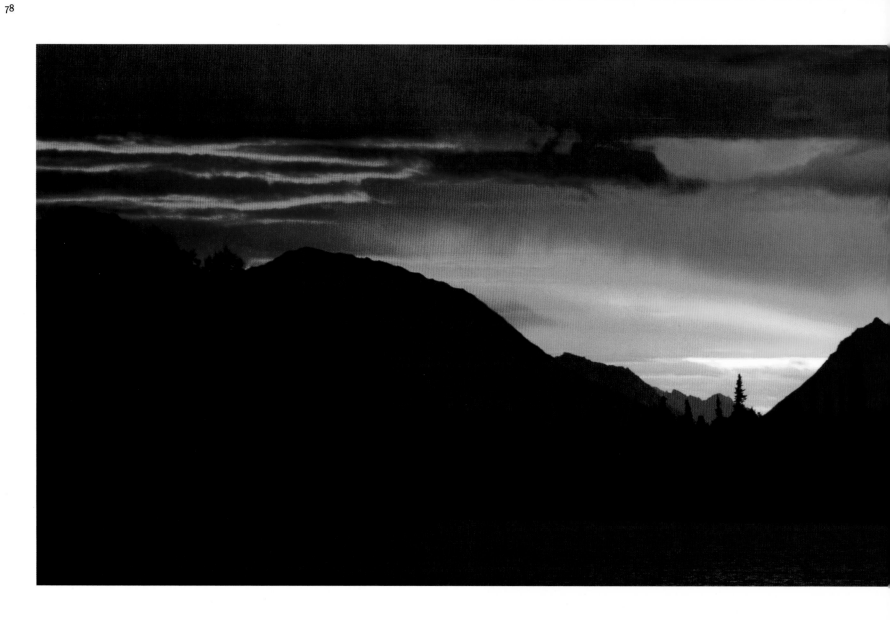

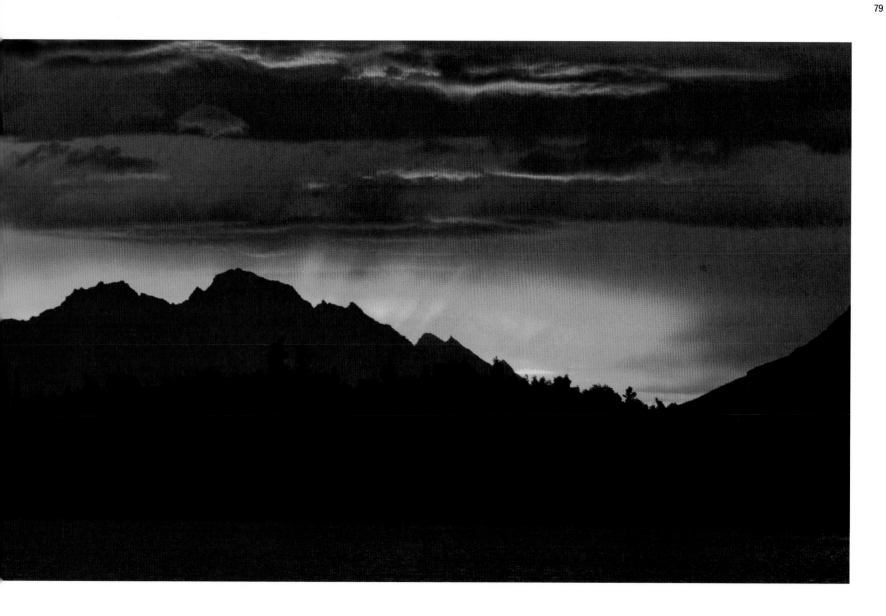

BRISTO

OL BAY

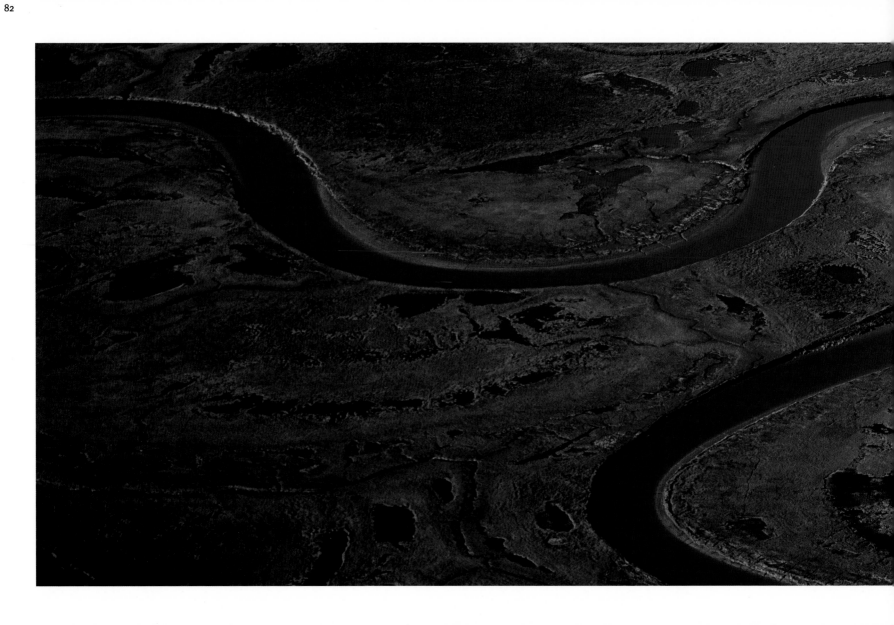

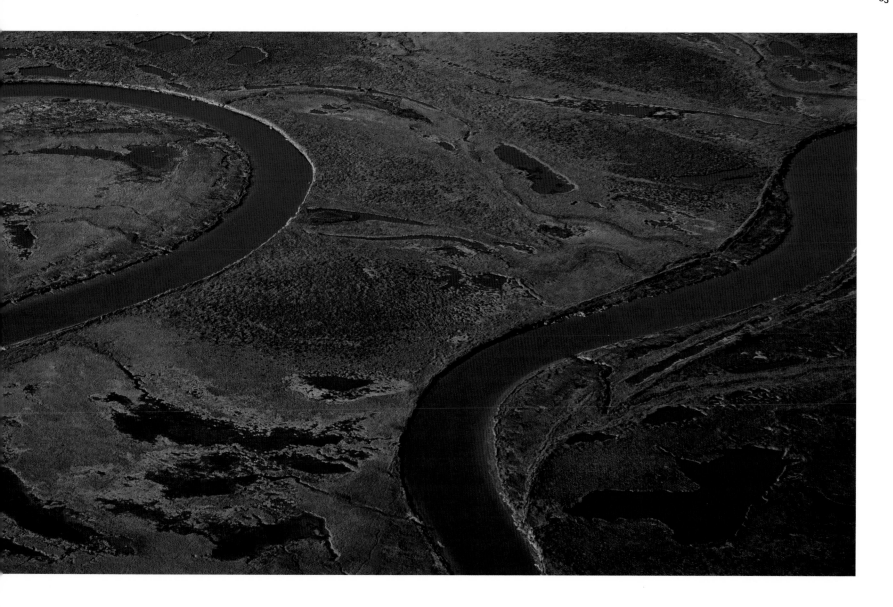

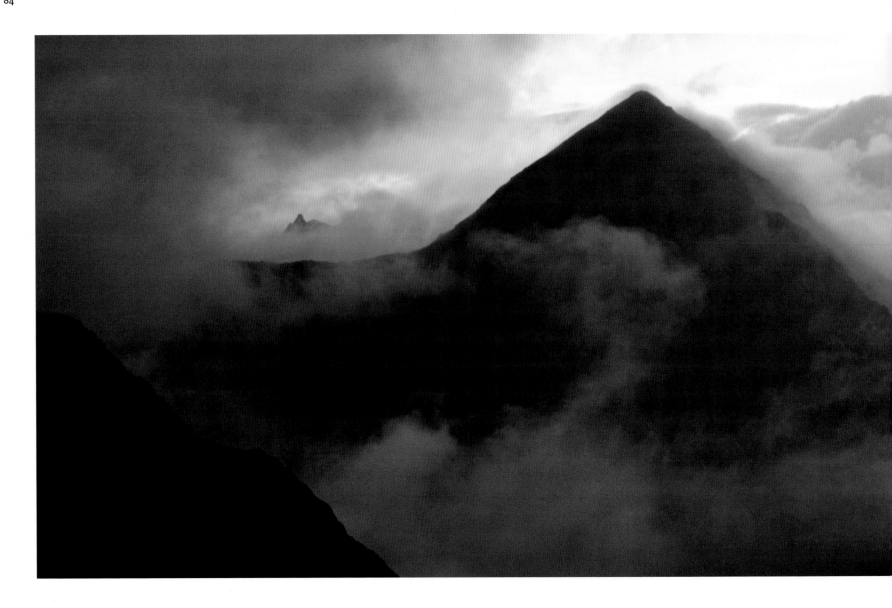

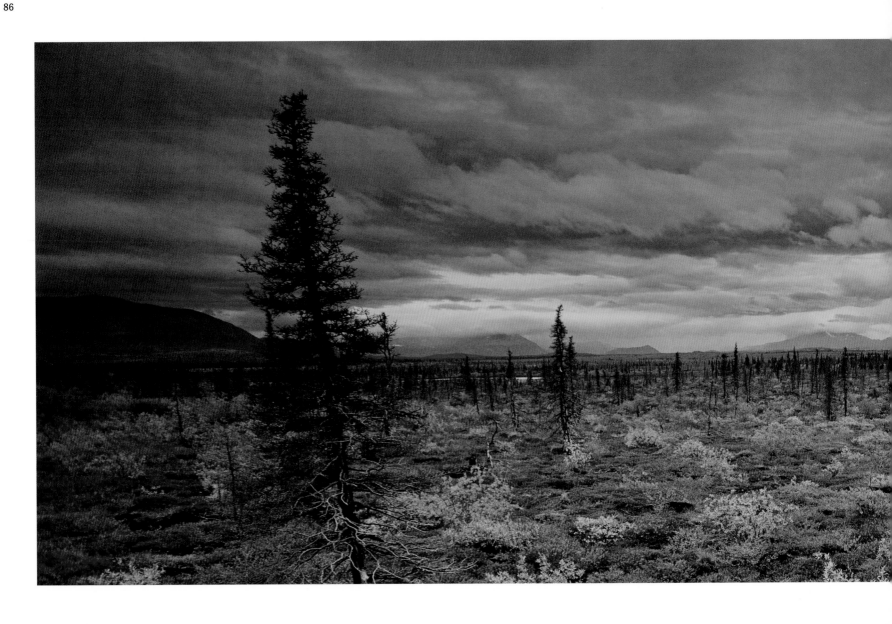

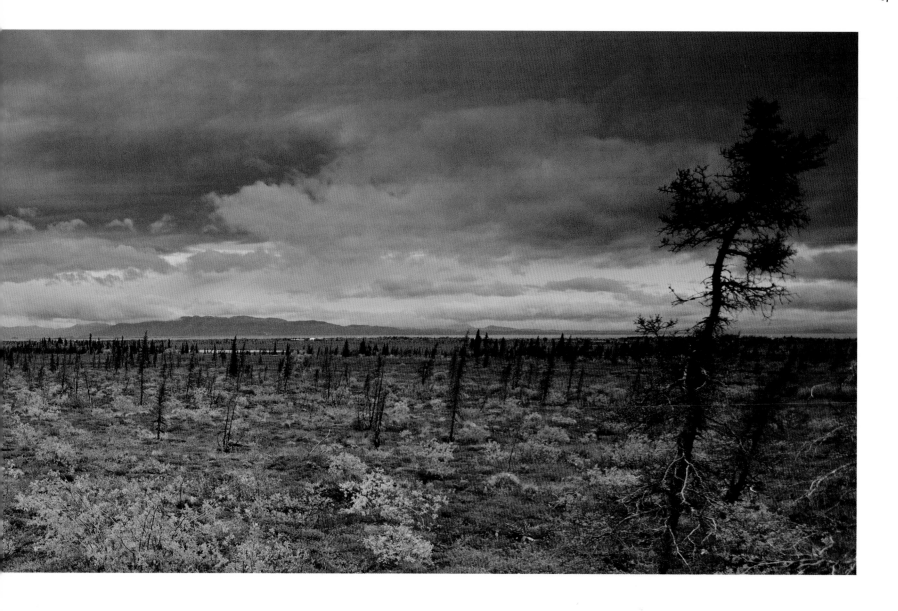

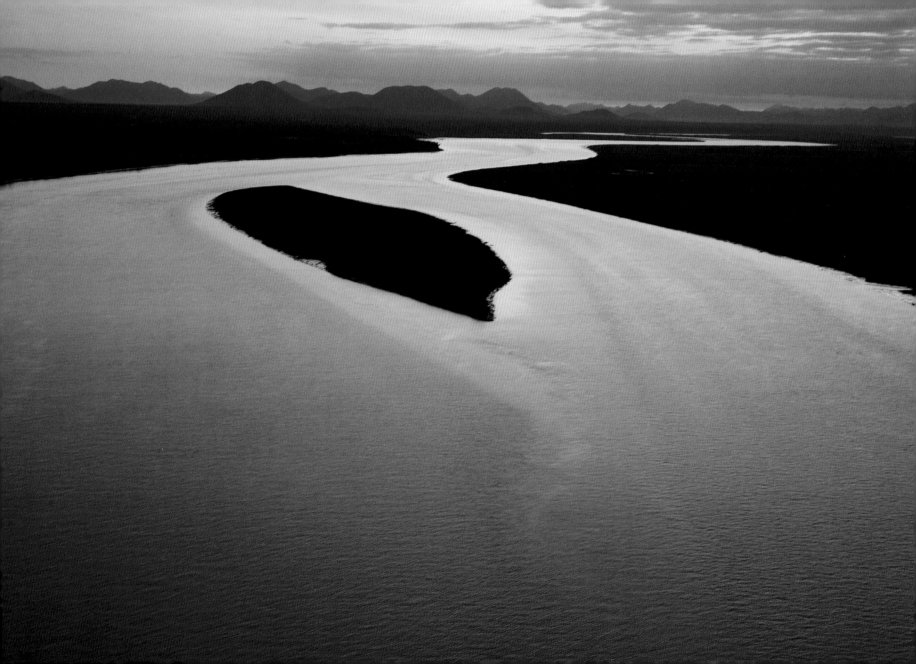

At its entrance into Bristol Bay, Wood River is a spawning ground for all five species of Pacific salmon: sockeye, king, pink, silver, and chum.

Preceding pages (82-87)
The Kanik River winds its way through the lowlands of the Togiak National Wildlife Refuge, which at 4.7 million acres is about the size of Rhode Island and Connecticut combined.

Clouds begin to break after a storm, exposing the Wood River Mountains. Nearby is an arm of Lake Nerka, an important salmon-spawning habitat.

The tundra's fall colors stretch out from the northern shore of Iliamna, the largest lake in Alaska and the eighth largest in the United States.

At more than 40,000 square miles—an area nearly the size of the state of Ohio—the region called Bristol Bay is a world unto itself. Its landscape runs the entire scope, from deep coniferous forest and vast expanses of open tundra to the state's largest and deepest lakes and its most spectacular mountain ranges. At the same time, it is walled off from the rest of the state by the formidable barrier of the Aleutian Range, Alaska Range, and Chigmit Mountains to the east, and the less imposing but still rugged Ahklun and Wood River Mountains to the northwest. Because of these barriers to travel, the Bristol Bay basin had for generations laid largely off-limits for all but the most intrepid explorers. Prior to the era of modern aircraft, visitors had the option to either cross several steep and imposing summits or travel through open, often dangerous seas around the Aleutian Islands.

The bay itself is the first large inlet north of the Alaska Range, stretching approximately 200 miles across to Cape Newenham on its northwest edge and reaching nearly as far shoreward, to the mouths of the most productive rivers on Earth. Inland, the surrounding mountain ranges cradle an immense basin, dotted with innumerable lakes large and small, and a series of serpentine rivers that flow through the countryside like veins in a vast circulatory system. They feed into the great arteries of the Nushagak and Kvichak Rivers, home to the world's most prolific runs of wild salmon.

The most likely route into the backcountry of Bristol Bay is Lake Clark Pass, and few pilots or passengers forget the surge of emotion, the sense of excitement and connectedness produced by a flight through the deep valleys and serrated spires of the pass. Reflecting on his first trip, pilot Rick Halford remembers approaching with awe. "It was truly overwhelming," he says. Even with 10,000 hours in the air and hundreds of flights through the pass, he adds, "It remains one of the most awe-inspiring places I've seen."

LAY OF THE LAND

Today a number of small commuter airlines and air taxi companies provide service to the 28 communities within Bristol Bay, though it is service that can be interrupted for days or even weeks by weather or volcanic activity. Aircraft have also allowed ready access to major visitor destinations, including Bristol Bay's two national parks. Established in 1980, Lake Clark National Park and Preserve is a four-million-acre gem that extends from the shores of Cook Inlet across a jagged array of mountains that includes the Redoubt and Iliamna Volcanoes, both active. The park continues westward, far into the foothills. There the rain and snowmelt from the hills feed an impressive series of deepwater lakes that culminates with the 50-mile-long crown jewel and park namesake, Lake Clark.

Within park boundaries also lies Twin Lakes, on the shores of which woodsman and wilderness craftsman extraordinaire Dick Proenneke literally carved out his unique backcountry home. His journal entries, which were published as *One Man's Wilderness* and projected in the documentary film *Alone in the Wilderness*, have made this a major destination for many who appreciate not only his keen sense of creativity in building—using only hand tools, many of which he designed—but also a wilderness ethic that sought to live in harmony as much as possible with the nature and wildlife around him. Proenneke lived an off-the-grid lifestyle in which he ingeniously reused literally everything. Old boxes were crafted into furniture and discarded gas cans formed into utensils, pots, and buckets. The Park Service has preserved his unique homestead—an homage to a simpler, more independent, and yet in many ways more industrious time.

Spanning a vast area south of Lake Clark is Katmai National Park and Preserve. Like much of the entire region, it encompasses several diverse ecosystems, sharing coastal Shelikof Strait with Kodiak Island, then straddling the Aleutian Range, before reaching

far into the lake region north of the village of Naknek. Within its realm lie nine active or dormant volcanoes, a centerpiece in the Ring of Fire and a force that has shaped this region's history and ecology for thousands of years. In an eruption ten times more powerful than the 1980 eruption of Mount St. Helens, the Novarupta Volcano in 1912 rocked the region in a series of earthquakes before exploding with a convulsive force that spewed glowing pumice across the land and sent ash and caustic gases high into the atmosphere, blanketing the entire Northern Hemisphere in a dark haze. One hundred miles away in Kodiak, it was reportedly black as night for days. Eventually more than a foot of volcanic ash settled over the entire town, collapsing roofs, contaminating drinking water, and virtually disabling the populace.

When the eruption was finished, 40 square miles of the surrounding forest, once lush and green, were completely buried under hundreds of feet of volcanic debris. The park was established in 1918 to preserve this area, known today as the Katmai caldera and the Valley of 10,000 Smokes. Often described as desolate, ethereal, and otherworldly, it stands as a testament to the power of nature and to one of the world's most dramatic geological events.

Outside the Valley of 10,000 Smokes, much of the 3.5 million acres of Katmai remains rich forest, rolling hills, towering mountains, and lush tundra. Katmai is also known for its prolific population of brown bears, most notably those that gather at Brooks Falls each summer. Normally solitary creatures, these shy bruins are attracted to the area in unusually large numbers by the salmon that converge in the lakes and rivers. This yearly gathering provides photographers and nature lovers with an unparalleled access to these amazing animals in their natural environment. The entire Bristol Bay region supports robust populations of bears, moose, and caribou. They share their Bristol Bay home

with a diverse variety of other mammals, including the red fox, wolf, lynx, wolverine, river otter, beaver, mink, marten, weasel, and porcupine. Along the coast, sea lions, seals, and sea otters often share the waters with orcas and right and beluga whales.

For many, springtime in Bristol Bay is a special time of year. Not only is the long winter coming to an end, but this is also when a boisterous spectacle occurs. Spread from the seaboard to the farthest plain, more than a quarter of a million migrating birds take over and in a cacophonous celebration of the new season seek out mates before busying themselves with the task of making nests and raising families. They arrive with the first open water from wintering grounds as distant as Mexico and Japan. The arctic tern, known to travel up to 25,000 miles, comes from as far away as Antarctica. Regardless of their route or departure date, they appear seemingly en masse and in a medley that is both expansive and exotic, and includes raptors, waterfowl, seabirds, shorebirds, and songbirds. One hundred and twenty-five species have been counted within Lake Clark National Park alone, with only a few hardy birds, such as the ptarmigan, spruce grouse, and raven, overwintering.

While some of this diverse terrain is in private hands or native ownership, much of the area is under state or federal jurisdiction where a majority of it is open for resource development. Within this area are a number of vitally important river systems, including the mighty Nushagak and Kvichak Rivers. The source of the Kvichak, which hosts the world's largest run of red, or sockeye, salmon, is Iliamna Lake. At 77 miles long, it is Alaska's largest freshwater lake and home to a rare and elusive population of freshwater seals.

Scattered throughout this country are a collection of mostly native settlements, from Ekwok and New Stuyahok on the shores of the Nushagak River to

Naknek and Egegik along the coast. Another is the village of Nondalton, near the boundary of Lake Clark National Park and Preserve. In 1970, well before establishment of the park, Clark Whitney, Jr.'s father took the position of principal at the local school and moved with his family into the village. By the age of 14, Whitney Jr. was running his own dog team and heading off by himself to tend a trapline. While his family spent only three years in the village, it left an indelible mark. Even as a teenager, Whitney Jr. would return to the region to spend several winters trapping, and he later guided hunters and fished commercially for 20 seasons in the bay.

"I got to know the whole place from hill to ocean," he says. Although Whitney Jr. now lives in town, it is easy to detect more than a hint of longing and nostalgia as he reminisces about his extended stays in such a wild place. "When you are out there," he says, "everything takes on a certain importance, even the winter full moon is an event." He describes the way it christens the land, casting a ghostly pall over the countryside, and the way the northern lights paint the sky in undulating streaks of green and red, and a quiet so intense as to be mindful. "With no distractions, you become acutely aware of everything around you," he says. "It's healthy, there's something spiritual about it, but at the same time," he cautions, in order to avoid cabin fever "you must also be doing something—building, hunting, trapping—something to stay busy with."

It was village life that primed him for being alone, and busy, in the bush. "Village life is at a different pace and you need to learn to do things on nature's schedule, not fight it," he says. "If you are stuck, for instance, by the weather, you must be able to just sit back and accept it. On the other hand, if nature gives you a gift, like the salmon returning or the caribou passing, you need to get out there and take advantage of it. And more importantly be thankful for it."

A walrus skull sits alone in a field of wildflowers. Each spring thousands of walruses return to the Walrus Islands in northern Bristol Bay to feed, rest, and sometimes die.

Following pages (96-99)
From above, the mountainous terrain of Wood-Tikchik State Park fades into the horizon.

The Newhalen River is one of numerous waterways that would be affected by the service road and accompanying slurry lines needed for the proposed Pebble Mine.

Clouds scrape by the snow-covered Iliamna Volcano, which last erupted before Europeans settled in the area.

About 100 miles from where Clark Whitney trapped as a boy sits Wood-Tikchik State Park, at 1.6 million acres the largest state park in the country, named for its two systems of clear-water lakes, which are critical to the salmon spawning cycle. In addition to all five varieties of salmon, the lakes support prodigious populations of rainbow trout, grayling, lake trout, char, and northern pike, making this a key destination for sportfishermen from around the globe.

Directly bordering the park and astride the northwest edge of Bristol Bay is Togiak National Wildlife Refuge. The refuge is another prime flyover and nesting spot for birds and a key spawning habitat for the region's fisheries, as well as an important breeding ground for 30 species of land mammals. It is also the summer home of the Pacific walrus. Spending the bulk of their winter on the pack ice of the Bering and Chukchi Seas, these imposing animals—the males average more than 2,700 pounds—migrate to the refuge and from June through October can be seen on a few of the largest regularly used "haulouts" in North America on Cape Peirce, within the refuge's walrus sanctuary, and on Round Island.

For some reason—whether it's quietly paddling a lake so secluded you almost feel guilty at the intrusion of your paddle into its stillness, or flying vast stretches of terrain unbroken by property lines or commerce—time spent in Bristol Bay seems to flow much faster than time spent elsewhere. Maybe it's the fullness of the days, watching trumpeter swans and arctic loons dipping in and out of a fog-draped shoreline, seeing bears cavorting with their cubs streamside, hearing gulls bickering overhead. Perhaps it's the physical exertion of hiking or rowing, or just watching intently. No matter the cause, even after an extended stay the regret of leaving will linger as soon as you climb aboard the plane and set a course for home. For one who finds solace in nature, there is no other place like it. It is a wilderness such as the lower 48 hasn't known in hundreds of years.

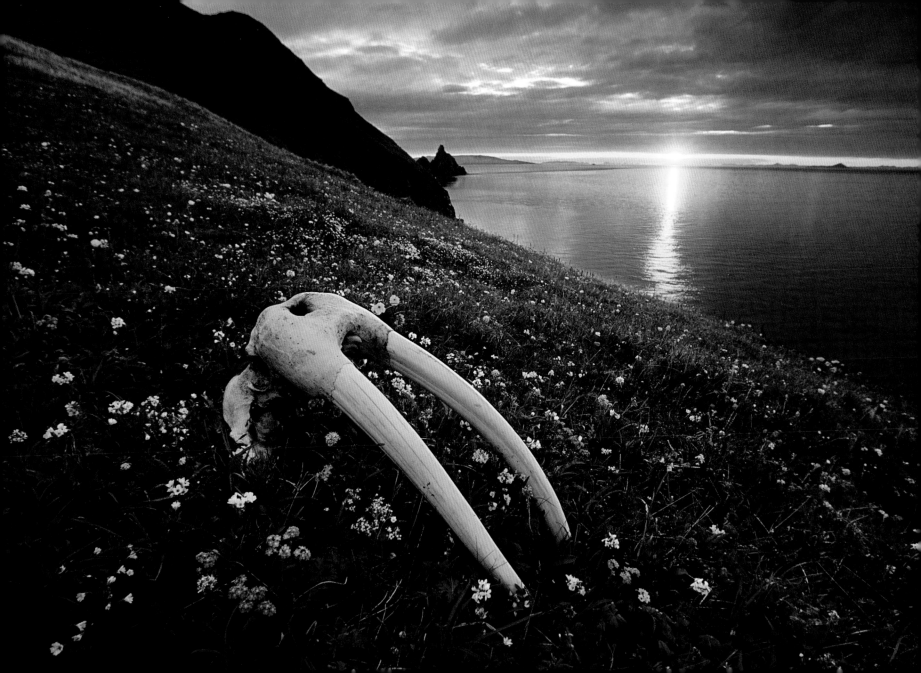

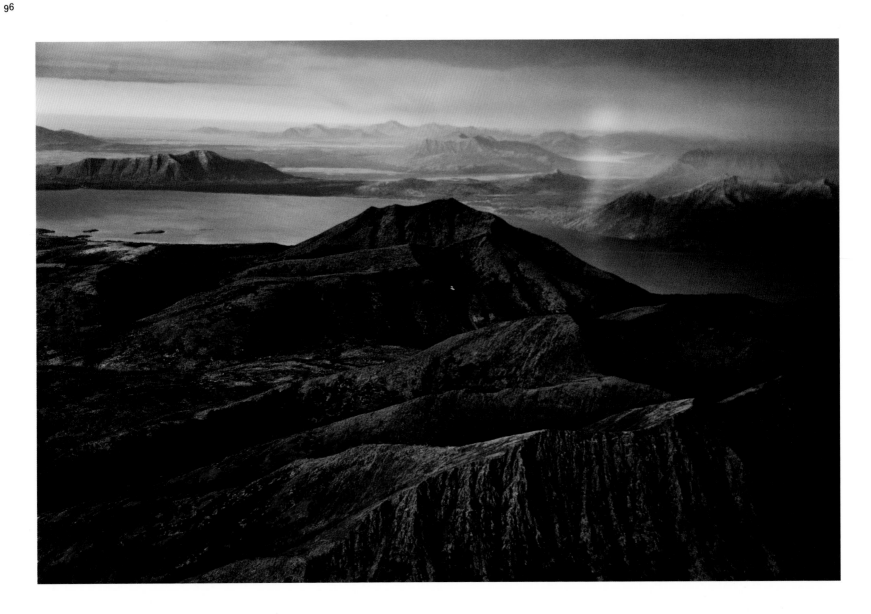

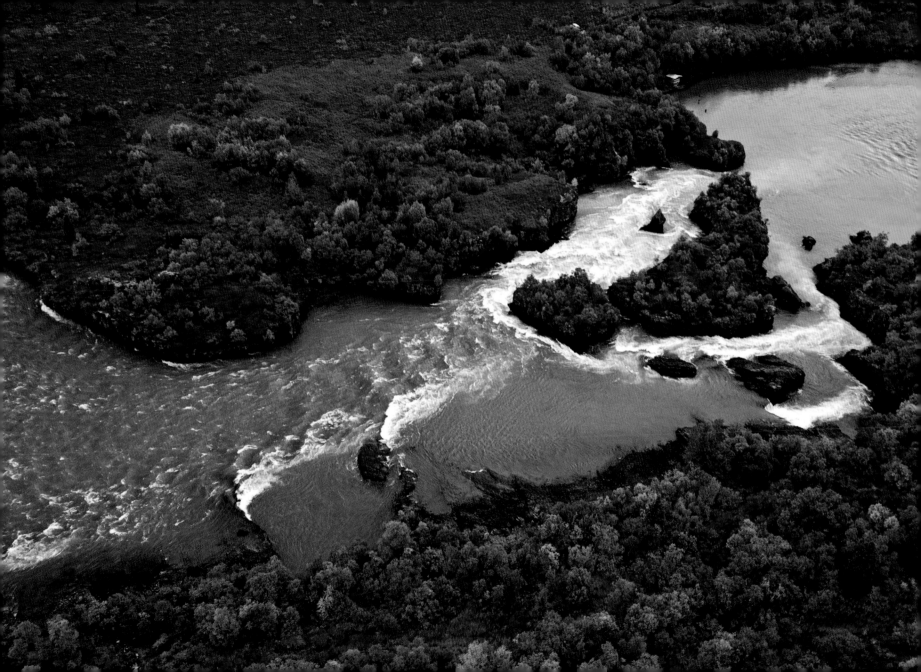

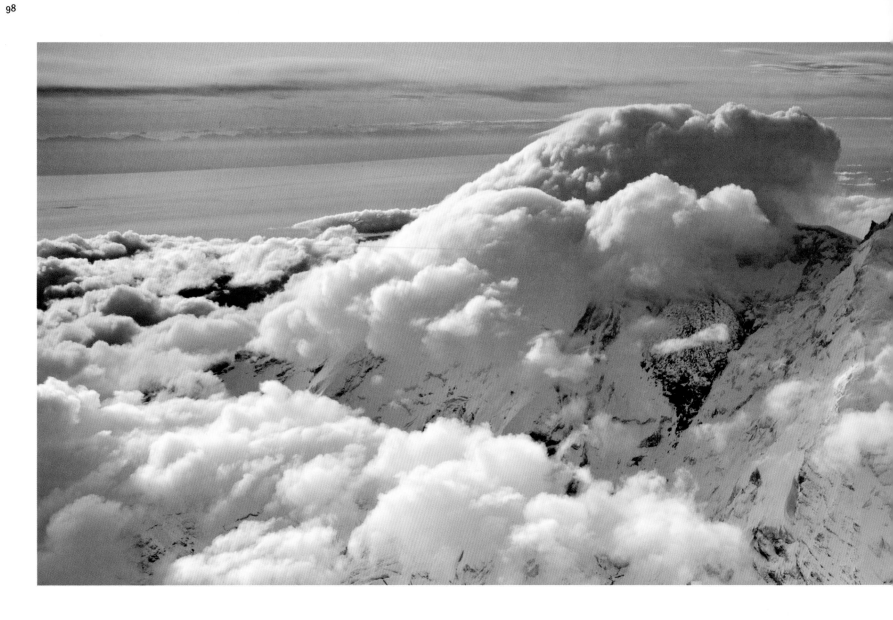

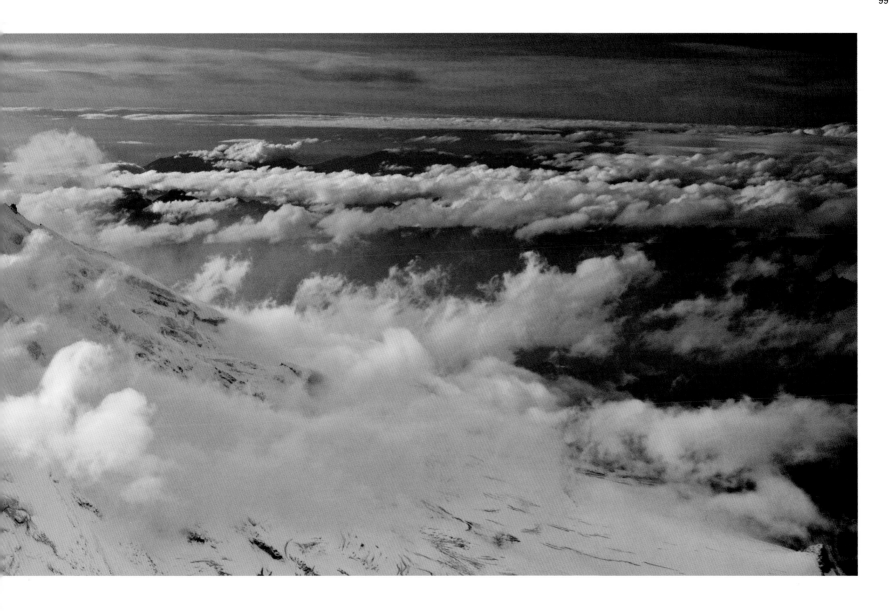

The wilderness of Chikuminuk Lake and Wood-Tikchik State Park displays an untouched nature that has mostly vanished from the lower 48 states.

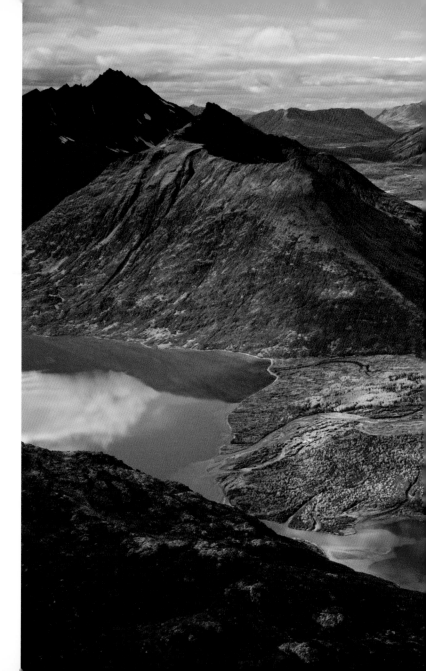

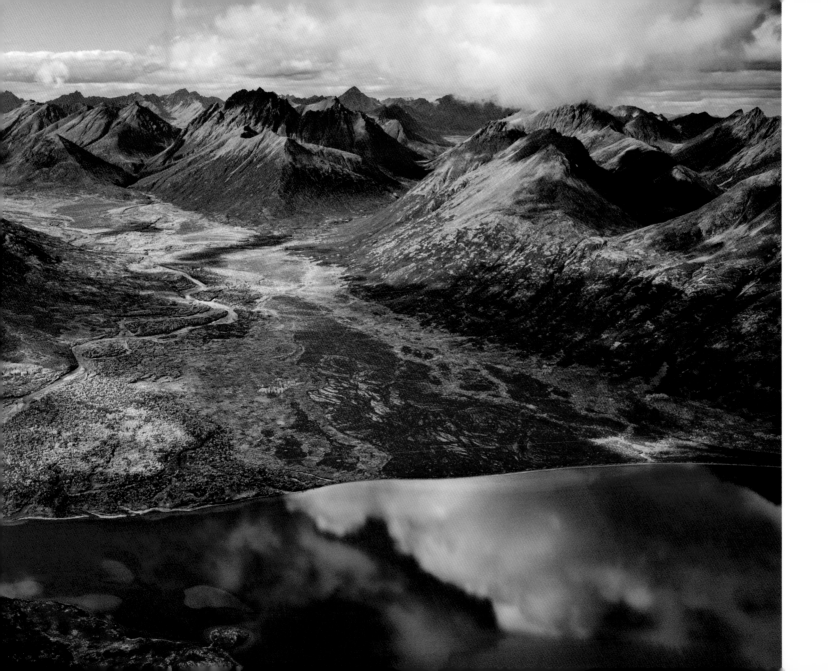

Cotton grass grows along the banks of Frying Pan Lake, where a tailings dam of the proposed Pebble Mine might go.

Opposite: The Nushagak River flows 280 miles, from the Alaska Range southwest to where it empties into Bristol Bay.

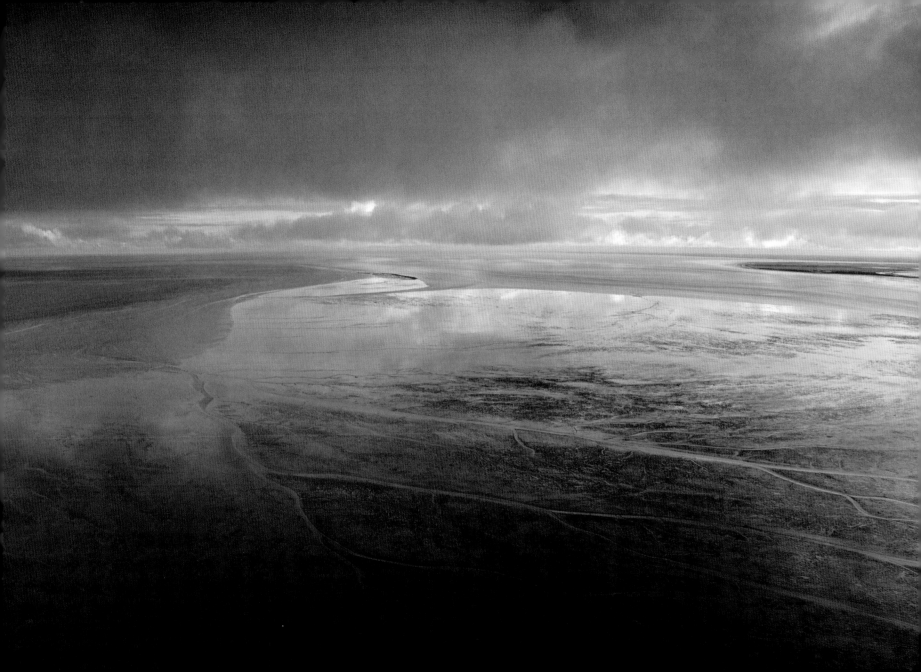

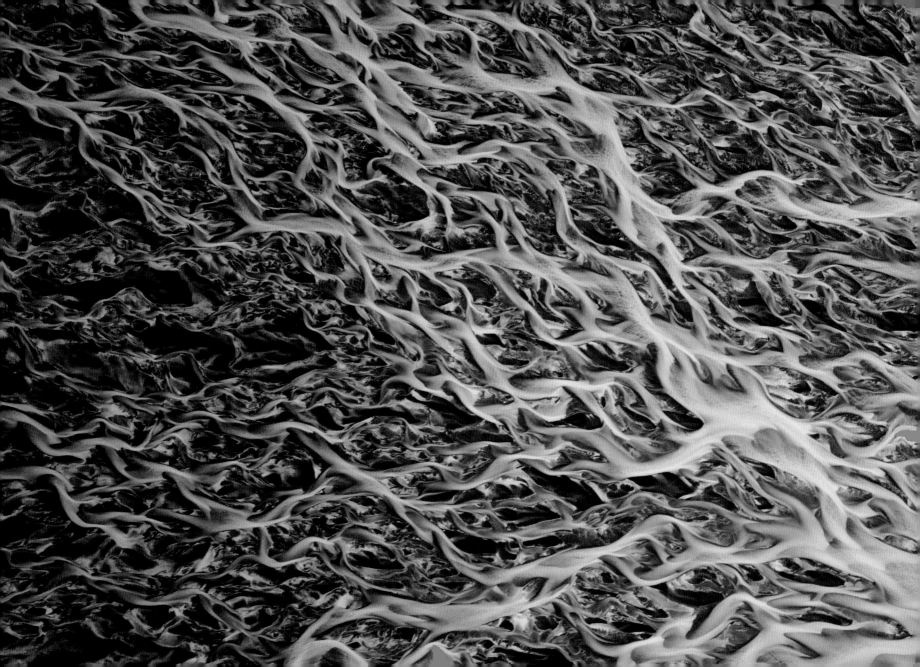

Meltwater from thawing snow and ice braids in an intricate pattern as it carries silt down into Cook Inlet.

A sandpiper stretches its wings near Lake Aleknagik. Aleknagik—meaning "wrong way home" in Yupik—is so named because boaters often get lost in the fog.

Opposite: This shy walrus appears to be hiding from the photographer's lens.

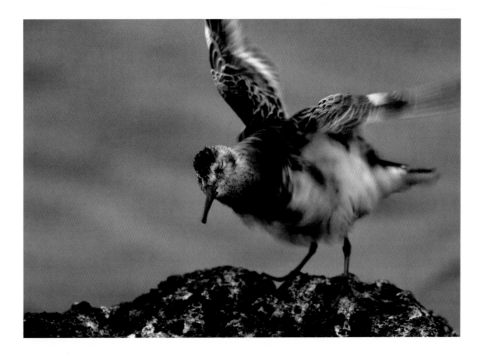

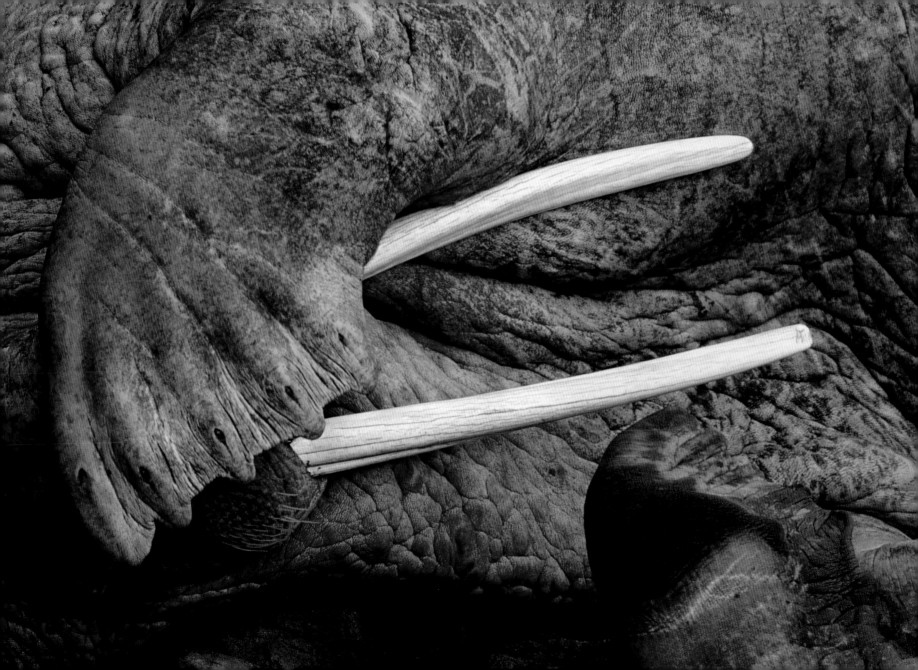

Wispy clouds dance among the spired peaks of the Wood River Mountains in Wood-Tikchik State Park, the nation's largest state park, with more than 1.6 million acres—about the size of Delaware.

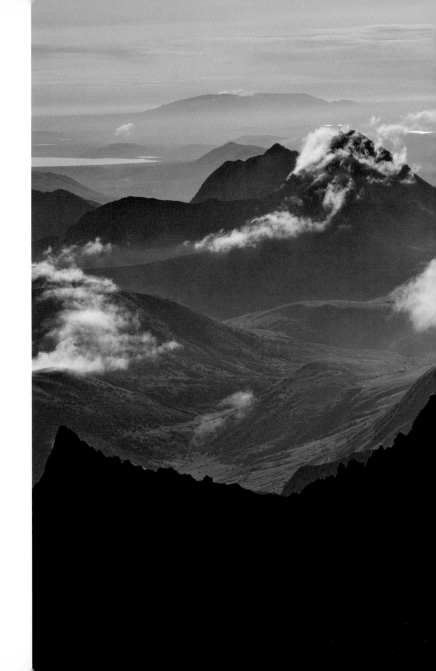

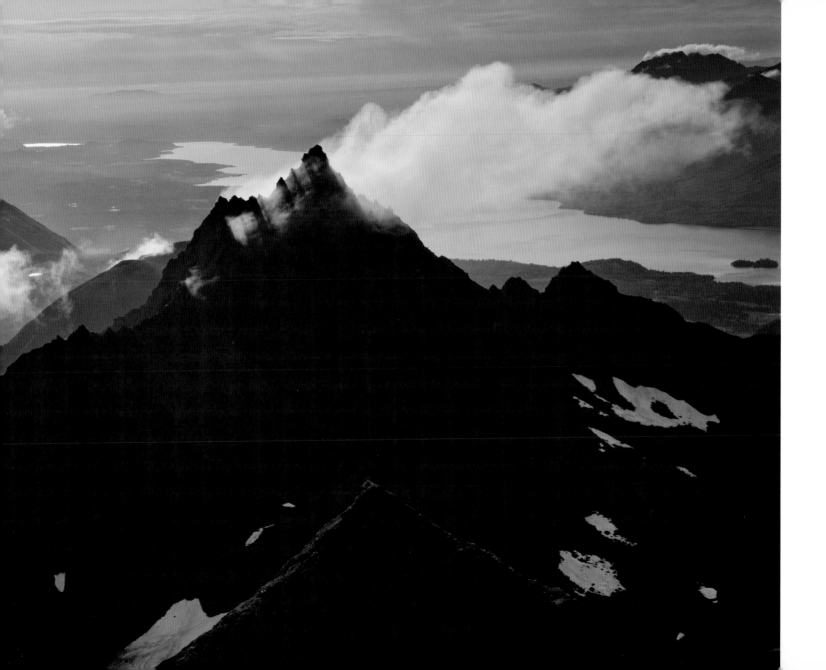

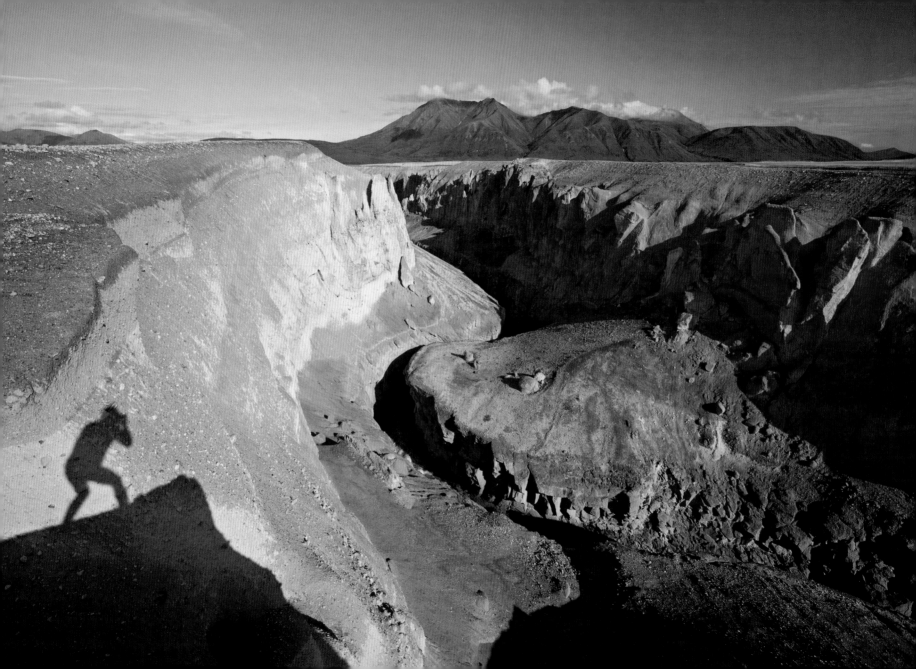

This male ptarmigan, or snow chicken, shows off his summer plumage in Katmai National Park and Preserve.

Opposite: A stream carves a canyon through the compacted ash of the Valley of 10,000 Smokes, where the nearby Novarupta Volcano erupted in 1912.

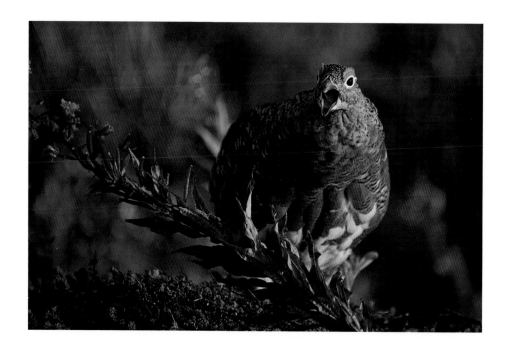

Frying Pan Lake lies in the middle of what would most likely be a tailings storage area if the proposed mine project is completed.

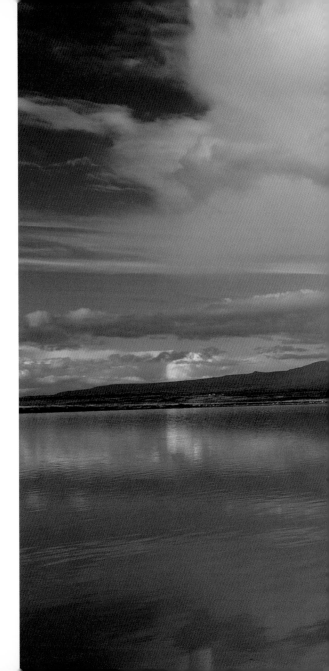

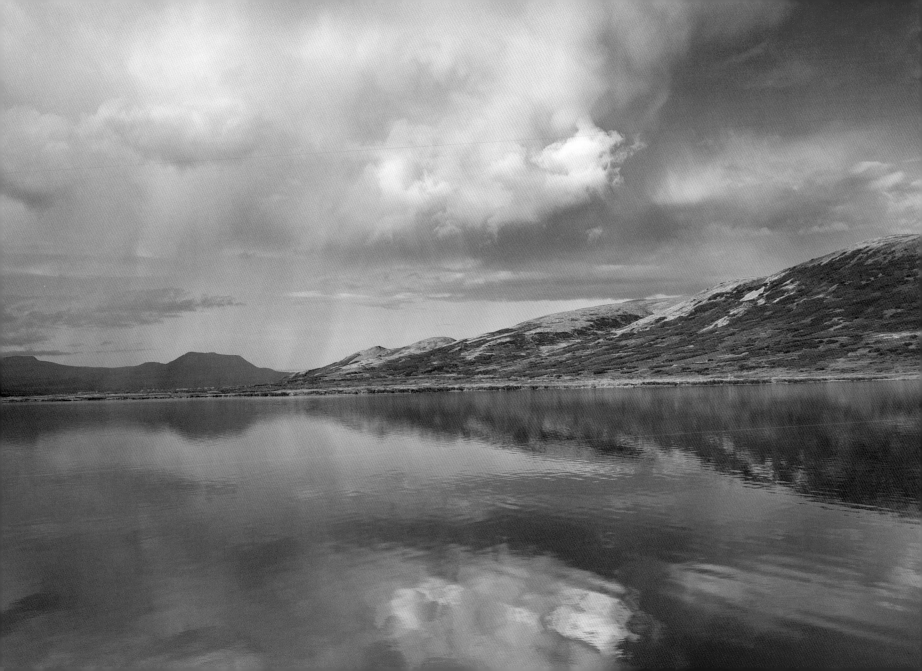

Fireweed grows along Aleknagik Lake
Road outside of Dillingham. Alaskans use
this colorful herb in the making of syrup,
candy, and other sweets.

Opposite: The sun sets on mountains bordering
Cook Inlet. Below lies a road used to carry
fishing boats from Cook Inlet to Iliamna Lake.

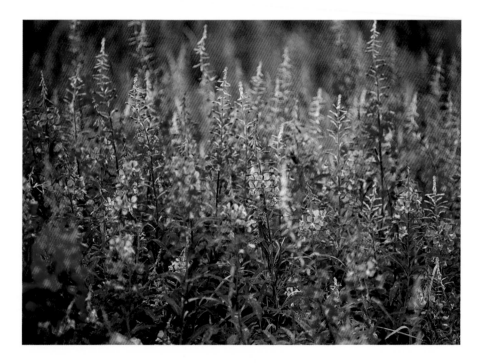

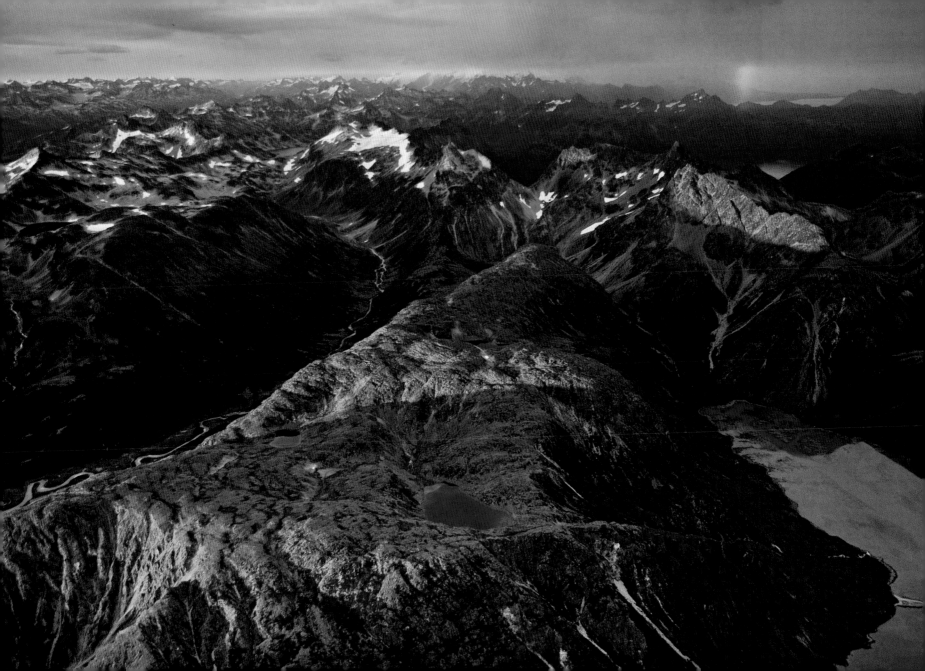

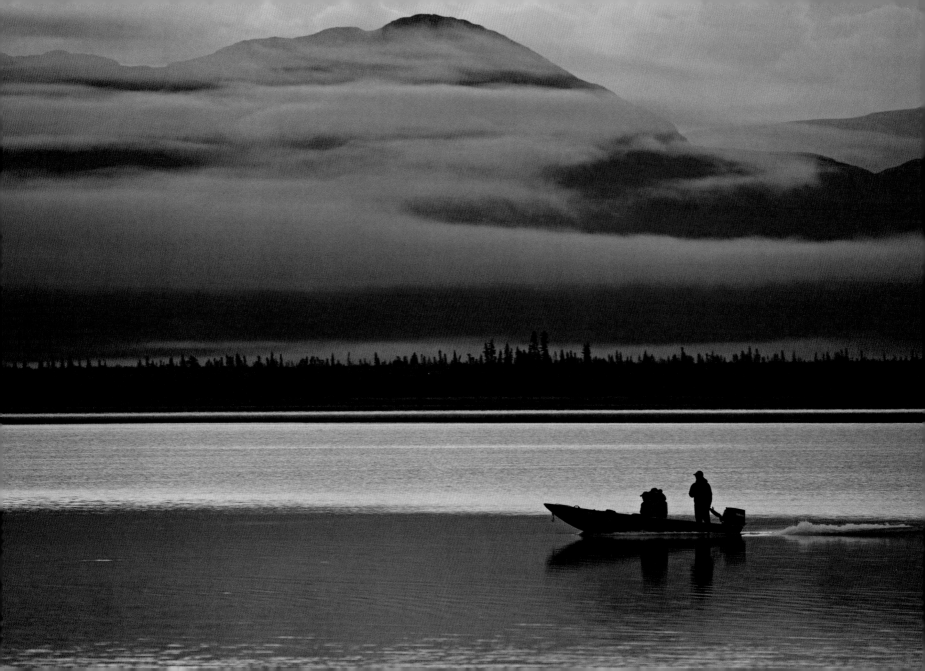

Sport fishermen rise early in hopes of getting an early start on Sixmile Lake near the native village of Nondalton.

If Alaska is a land of extremes, the Bristol Bay region might be called the land of extreme salmon. No other place on the entire planet sustains a fisheries resource quite as astounding as the sockeye and king salmon, and their supporting cast of silver, chum, and pink salmon, that make their epic journey here every year, sometimes hundreds of miles, to their natal streams.

Dressed to the hilt in their spawning colors, millions of fish literally clog the entire system, from the fastest flowing river to the tiniest stream, turning the water crimson. For millennia they have returned, the life-blood of the region, feeding the native people for generations and today bolstering the local economy to the tune of $350 million a year.

"They are an integral part of the whole circle of life," explains Carol Ann Woody, Ph.D., one of Alaska's most prominent fisheries scientists. In one of nature's greatest feats, these remarkable creatures seek out the very place of their birth. There they dig what is called a redd, a nest in which to lay their eggs, and bury them beneath a blanket of gravel to incubate throughout the winter and in the spring produce the next great generation of wild salmon.

Once they are finished with this momentous process, they simply die. Millions are set adrift, the life slowly fading from their bodies, in a profound ritual of renewal; for it is in this mass die-off that a rich bounty springs. In a monumental cycle, perpetuated in memoriam, they feed the entire system, supplying vital nutrients to the vegetation along the shore, which in turn nourishes moose and caribou, which in turn feed the wolves and bears. Their decaying flesh and the eggs they leave behind sustain all the other fish species as well. The resident rainbow trout, Dolly Varden trout, lake trout, and grayling that grow to such substantial size and proliferate throughout the system do so through the grace of their wild anadromous cousins, the salmon.

LAND OF THE SALMON

Woody describes the process as blood flowing into capillaries, feeding cells, feeding the land. "For a scientist," she says, "it is a dream come true." Having spent her early years revitalizing streams in the lower 48, "where the salmon were so few and far between you could practically name them," she knew when she arrived in Bristol Bay it was the perfect setting. "Not only had I never seen anything so beautiful," she says, "but to have the opportunity to see salmon in such incredible numbers, it was, and still is, mind-boggling."

It is also important, she contends, because the discoveries that scientists make here in such a large, unspoiled natural ecosystem will tell them how an impaired one should work. "This is the greatest living natural laboratory on the planet, where streams still run free and clean, and you can actually see fish, completely free from the impact of humans, that behave like they are supposed to. Hatchery fish don't behave like wild fish, so what we learn here about the behavior of native fish,

how these systems are supposed to function, will help us fix salmon streams elsewhere. It is an opportunity that doesn't come around for scientists often."

Part of the reason for the strength and size of these runs is their genetic diversity. Over the past 10,000 years, individual stocks have adapted to individual streams. Some spawn late, some early. Some have adapted to a warmer or colder incubation temperature, hatching in sync with a particular stream and when food is available. If one of these runs doesn't fare well, the others make up for it, each an essential component of a complex and healthy whole. It is also the remoteness of the region. The range of the salmon is so extensive that in some cases biologists know very little about them and often don't even have vital data on fish counts in certain streams or the genetics of the fish that spawn there.

What they do know is that salmon return to Bristol Bay on a scale that is unheard of anywhere else. In 2008 more

than 40 million sockeye salmon alone returned to these waters. For the people of the bay it is an event that each spring fills the air with boundless anticipation. The canneries along the coast, a series of self-contained settlements of corrugated metal buildings, suddenly morph to life as forklifts, cranes, and a flotilla of vessels gear up for the coming season. In just about any village, you will pass a harbor or cannery yard filled with old boats held suspended in dry dock, perched high on rusty barrels and 2-by-4s, either being diligently worked—sanded, caulked, and painted in a frenzy—or sitting neglected, dilapidated, and forgotten. The smells of dreams fill the air, those of fiberglass and fresh paint mixing with the dry rot of those long gone, those ghosts of each passing season hanging on the breeze, waiting to be caught and resurrected by a crop of newcomers.

Commercial fishing in Bristol Bay is a way of life, and many a gillnetter admits to having more than a bit of the gambler's spirit. "You'd have to," said one new fisherman, "in order to invest in a boat and permit and bet your savings on what the fish might do." But most wouldn't have it any other way, the excitement of joining the fray, the frantic countdown to each season's first opening, the jockeying for position, negotiating a web of outstretched nets in a high-stakes game of chicken. It is what they live for.

Farther inland, as the mayhem of commercial fishing commences, a sometimes more subdued—but for the participant just as important—ritual occurs. It begins with the sorting of gear, the odor of old reel oil and moldering hackle feathers melding with the simple thoughts of sportfishing seasons long past. Perhaps it is a grandfather's streamside pipe smoke or a random piece of sage advice that rises in memory with the stringing of new fly line in preparation to fish.

Each year fishermen walk the tundra, stepping over ankle-bending tussocks, finally rounding the top of

any number of small knolls throughout this land and being suddenly confronted by a maze of pothole lakes that blend into a vast panorama. Through this mesh of dense vegetation and interconnected waterways, there will likely lay a small stream. Even from a distance a blazing streak of bright red runs across the otherwise flat tones of the midsummer landscape. On approach it will become obvious it is a stream red not from runoff or waste but from the natural living wonder that epitomizes Bristol Bay. The wild salmon are so thick that if you were to step into the stream, it would likely cause a stampede, the ensuing wake enough to knock you off your feet.

But these fish, long tired and weary from their journey, will not be the fisherman's target. It will be the trout, Dolly Varden, and grayling that stack behind them, ravenously slurping up any stray salmon eggs that might drift their way. Stationing themselves along the shore, most new fishermen will invariably stare in astonish-

ment. They will cast almost by rote, completely taken by the distant mountains and greedily tasting the rich scent of willow and fireweed that spice the air. No telling how many casts they will lay out before it happens, their fly finally crossing a riffle and skirting the abyss of deep water, startling them out of their reverie with an incredible jolt. As line draws tight, the entire hole will erupt in panic as a single fish leaps, breaking the surface in a blast of scales and merging into a montage of black dots and a swirl of pink. In the intervening moments, amidst the sudden sweet panic of playing a large trout, time will rush to a standstill. Every aspect of the fisher's being will be tied for an instant to the stream through this fish—the blush of its gill plates, the silver and pleated curve of its back now embedded, along with perhaps that faint trace of a grandfather's pipe smoke, in the current of his heart.

It is moments like these that we as fishermen are in search of. From the first time we pick up a toy rod and

dunk worms for panfish, it is this connection to each other, to the past and to place, we seek. It is perhaps what makes Bristol Bay the ultimate destination, a mecca for anglers of all kinds. Whether it's the purist contemplatively dabbing dry flies for grayling or the sportsman seeking out the arm-wrenching thrill of the chinook, they regularly make the pilgrimage to feast on the region's grandeur and to experience its incomparable bounty. "This is definitely it," says John Holman, a lodge owner and lifelong Alaskan who has fished extensively all over the state. "Bristol Bay remains, year in and year out, *the* best fishing you'll find anywhere. It truly is one of a kind."

Still, for others who have grown up here and rely on fishing for their sustenance, it is just something important you do. Melanie Brown, a woman of Yupik and Supiak descent, spent her childhood summers fishing the very same commercial set net and subsistence fish camp that her great-grandfather fished.

"The salmon," she says, "run totally on instinct, and I feel like I have that instinct too, to return here each year. But it's also a conscious effort to be a part of it, to see this amazing place and to see the fish come in. They are a force as powerful as the elements, the wind and tide that bring them here, and I'm still amazed when they arrive every year en masse."

Today Melanie lives in Anchorage after having spent five years in New York pursuing an acting career. But every summer, she returns to fish camp with her young children. "It was part of my education," she says about living in New York, "but deep down I knew I'd be back. It was going away that really allowed me to see the parallel between what I was doing and the salmon. It doesn't matter how far you go, the pull is still there. It's also the familial ties. It's the people that return every year, the cousins and friends that you don't see anyplace else; they come back for the same reason: the salmon. They are what unify us."

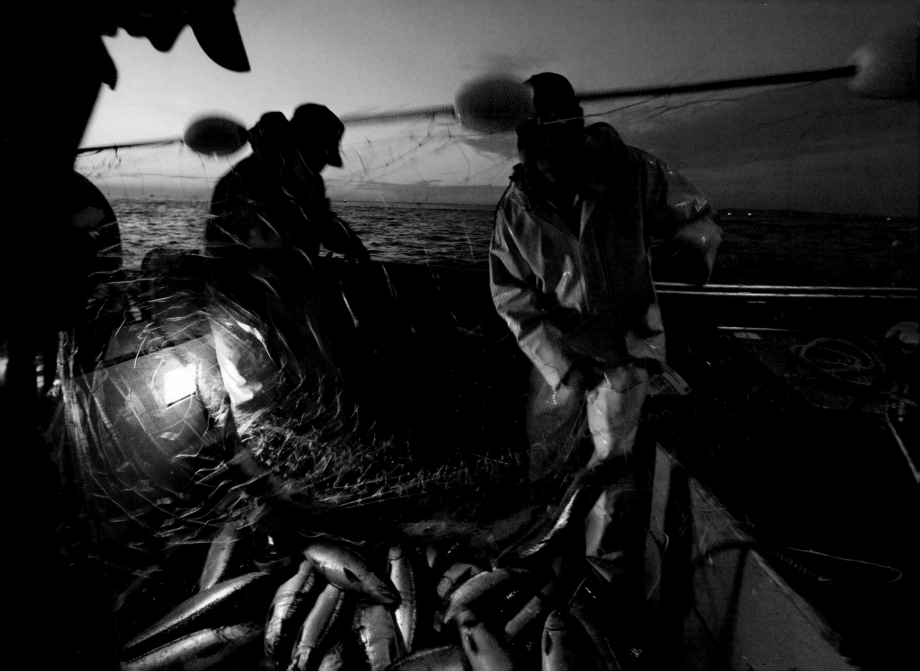

Sockeye salmon are caught in a drift gill net from one of Captain Ben Blakey's boats. Sockeyes are considered by many the most flavorful salmon, and they capture a high price on the market.

Opposite: Commercial fishermen pull in a drift gill net at dusk on Bristol Bay. In an average year more than 40 million salmon travel through the bay to their spawning grounds.

Following pages (124-125)
Bristol Bay is home to the largest haul of sockeye salmon in the world, and fishermen can earn a year's wages in only a few months during the summer salmon runs.

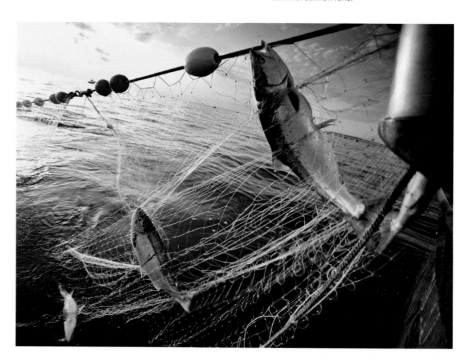

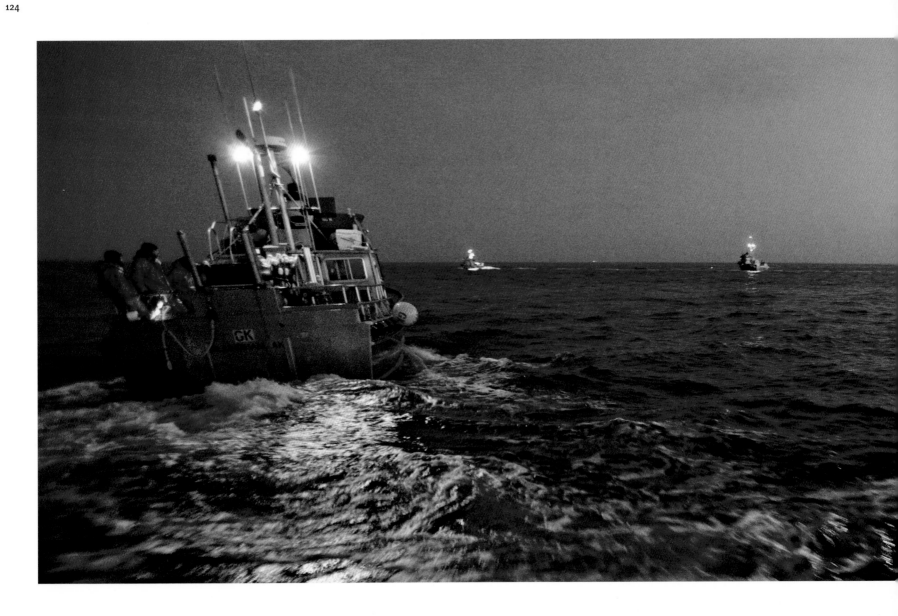

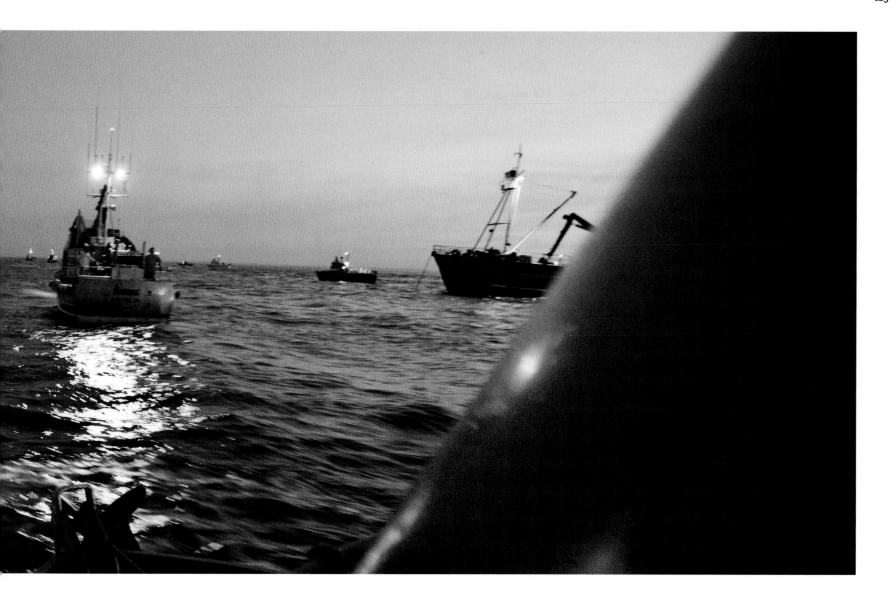

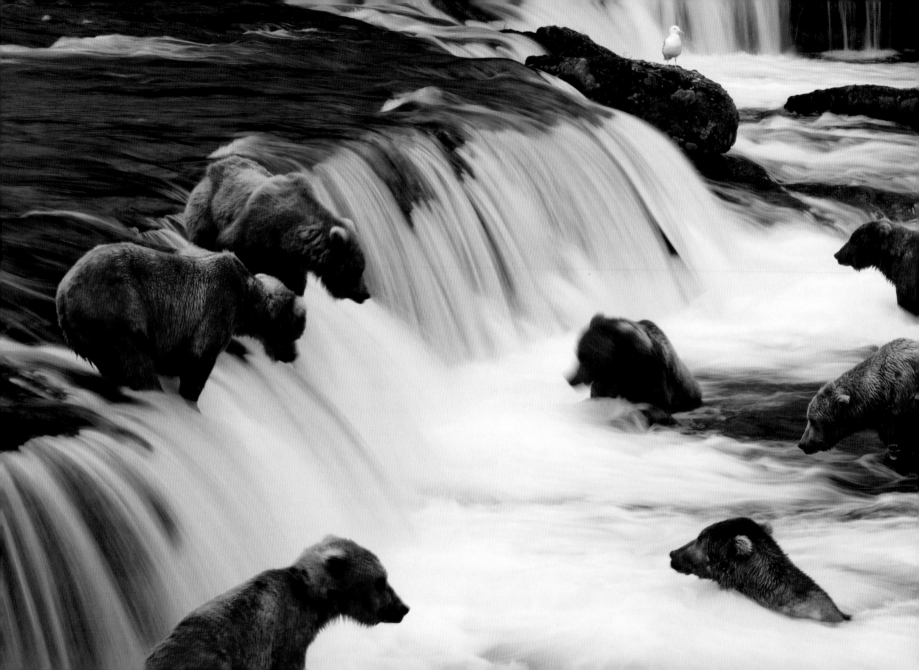

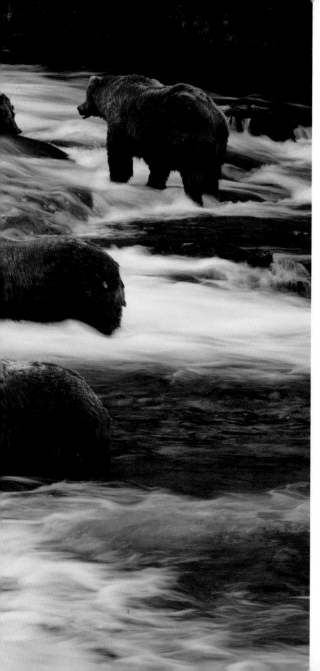

Although brown bears are normally solitary creatures, they congregate at places like Brooks Falls in the summer to catch and eat spawning salmon.

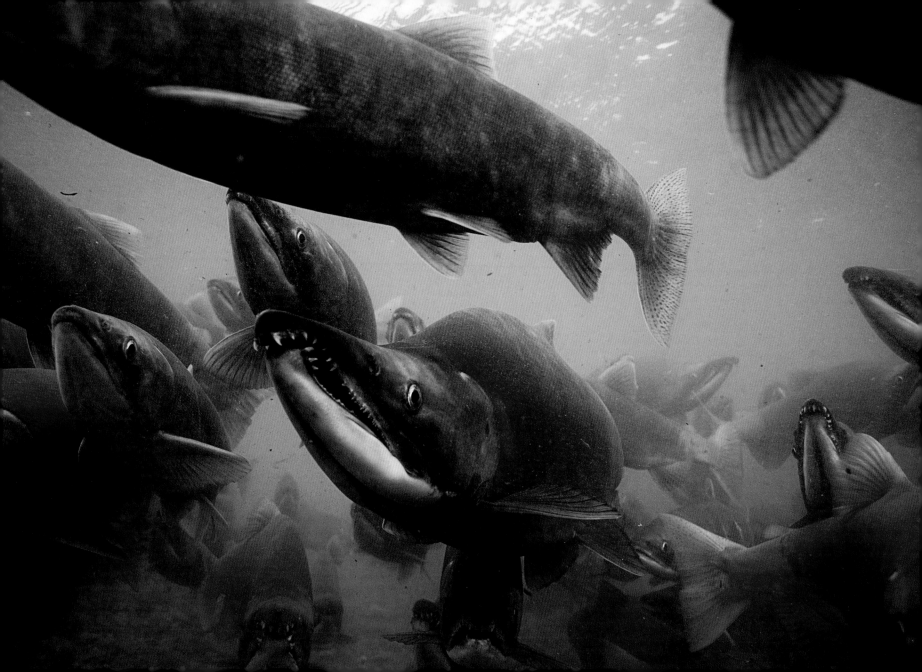

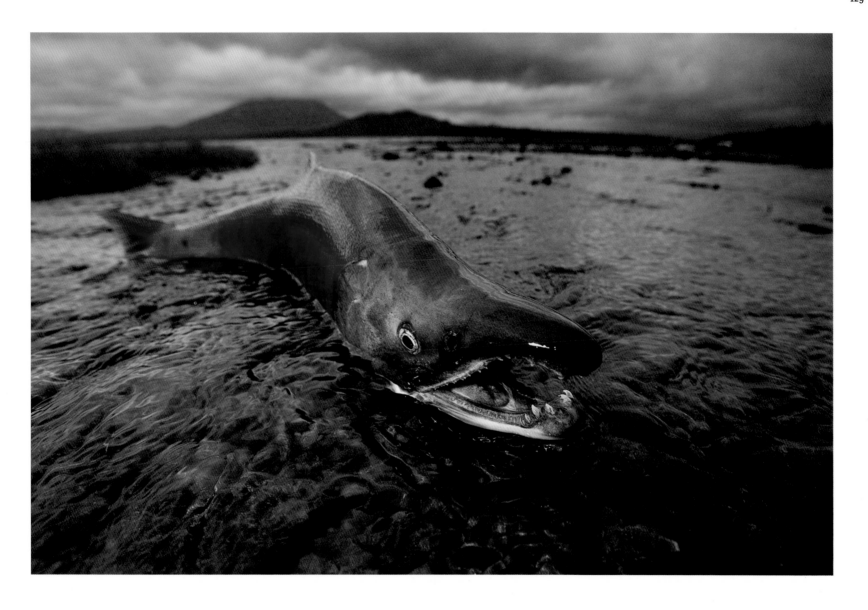

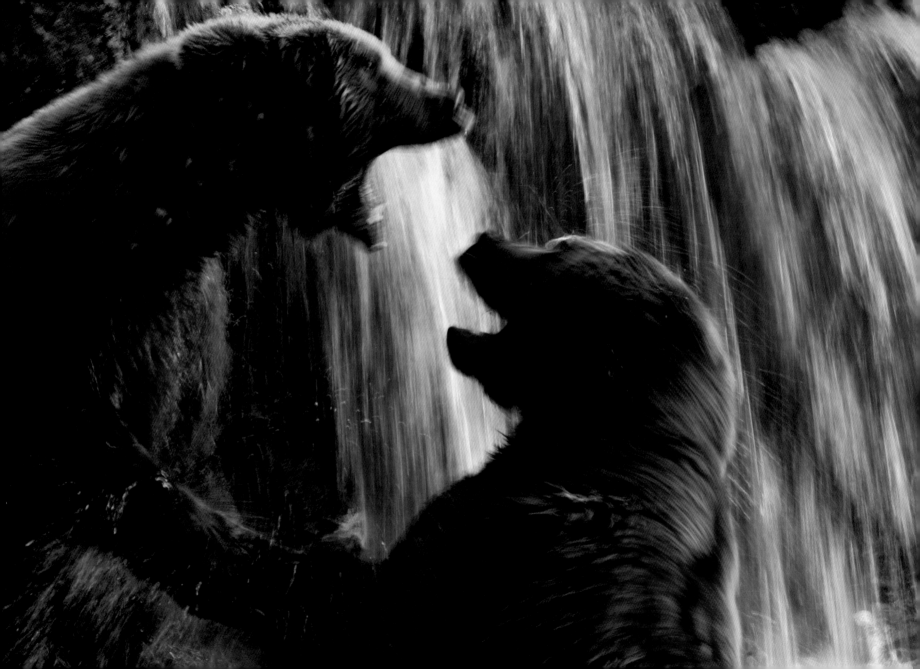

This mother brown bear flees the scene with her cub after snapping up a salmon at Brooks Falls.

Opposite: There may be plenty of salmon to go around, but these bears are fighting at a crowded falls for the best fishing spot.

Preceding pages (128-129)
Upon their return to fresh waters, the bodies of sockeye salmon turn a brilliant red, while their heads become olive green with elongated, hooked jaws.

A male salmon rests on his long voyage back to the waters of his birth. These migrating salmon die shortly after breeding.

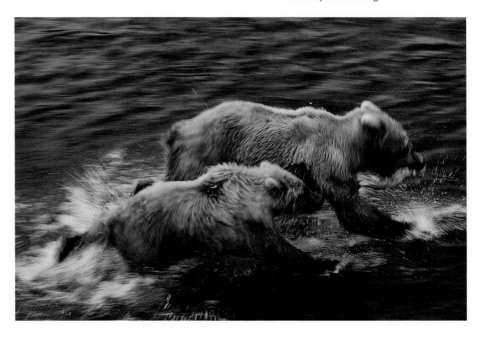

Augustine Volcano sits on an island made
out of deposits from its past eruptions,
the most recent occurring in 2006.

Following pages (134-135)
A speeding boat leaves trails through the
waters of Lake Aleknagik.

After a long day of fishing for rainbow trout,
two sportfishermen wade through Upper
Talarik Creek toward their seaplane.

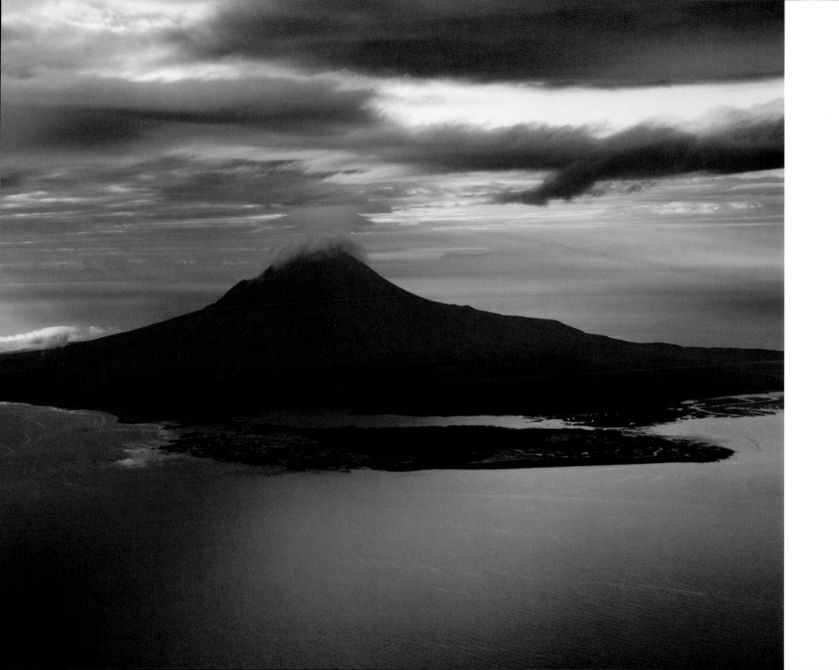

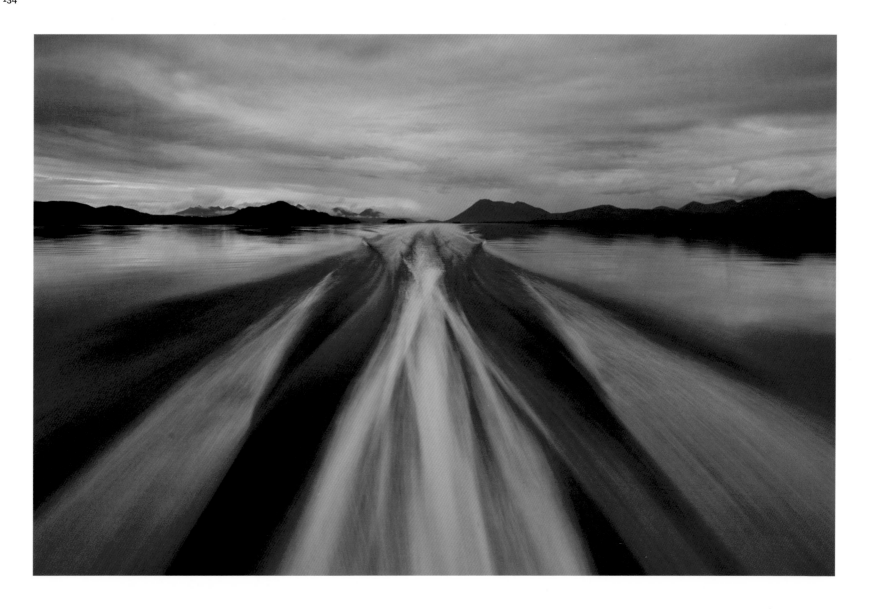

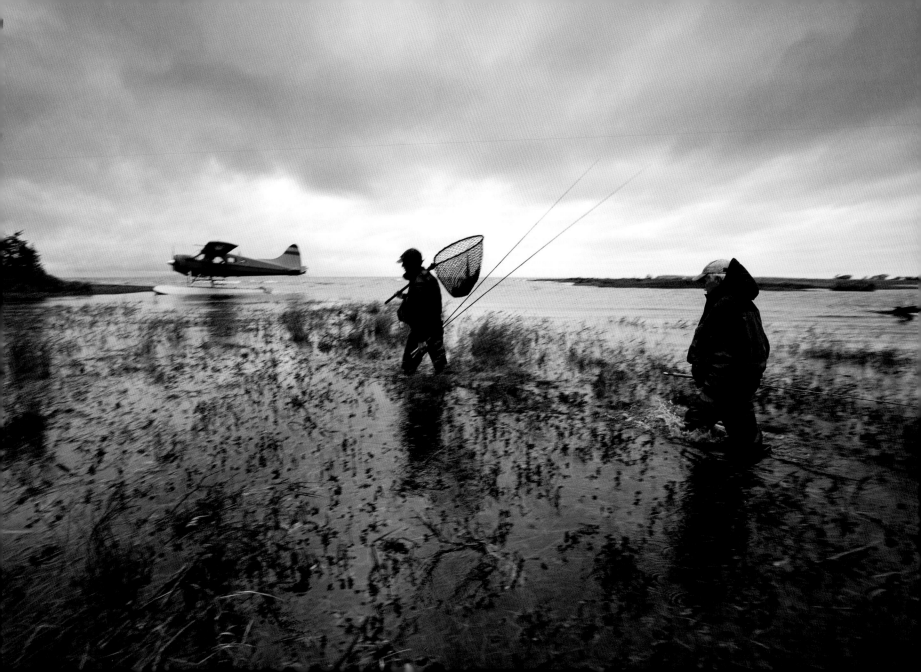

136

A fly fisherman casts off from the bow of his boat on the Kvichak River. Local lodges depend on the sustainability of the salmon runs in the Bristol Bay area.

Following pages (138-139)
Two bear cubs dry off in the tall grass on the banks of the Brooks River.

Bristol Bay bird-watchers can get close views of stunning birds of prey, such as this golden eagle.

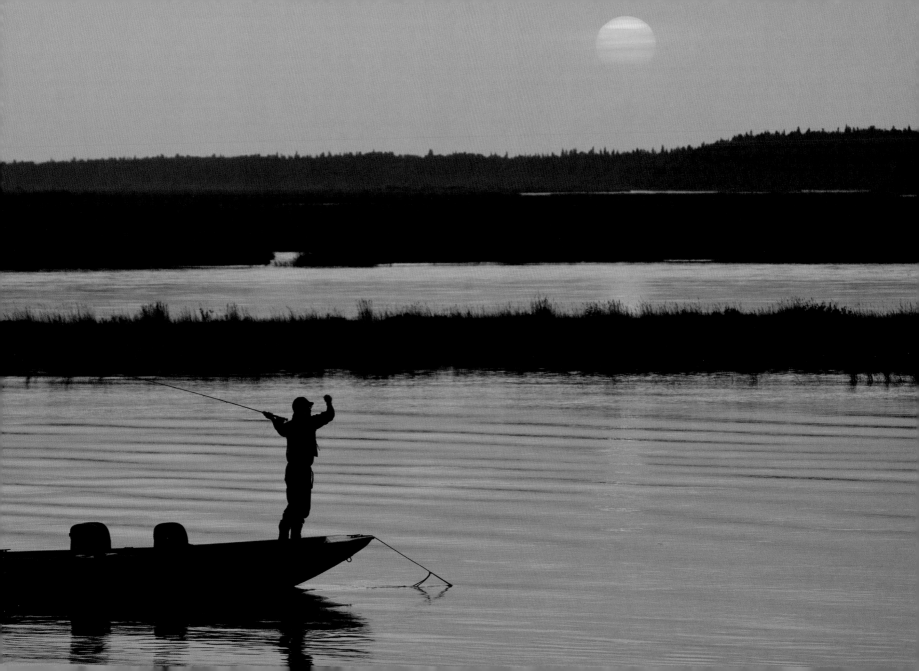

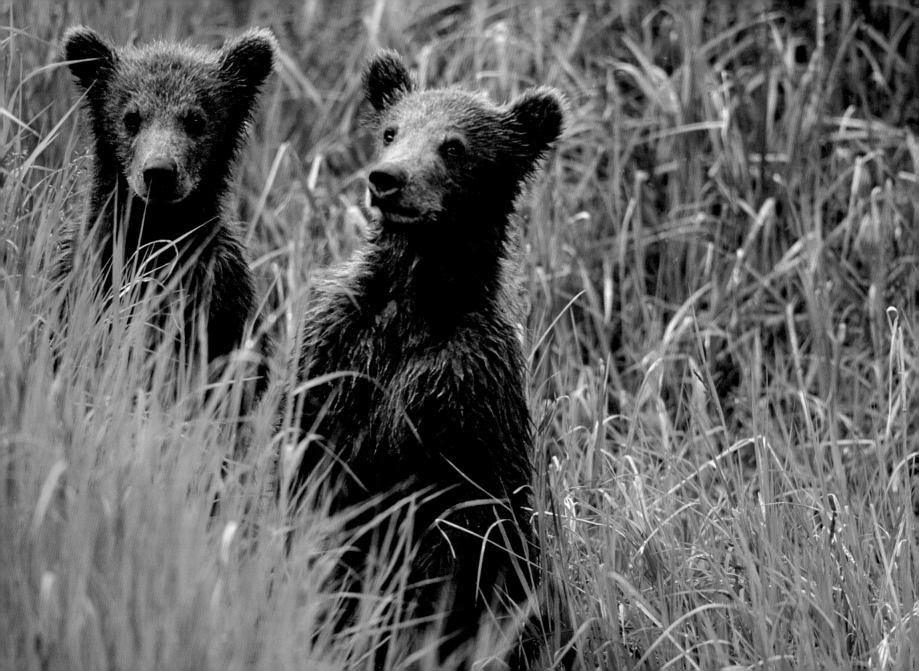

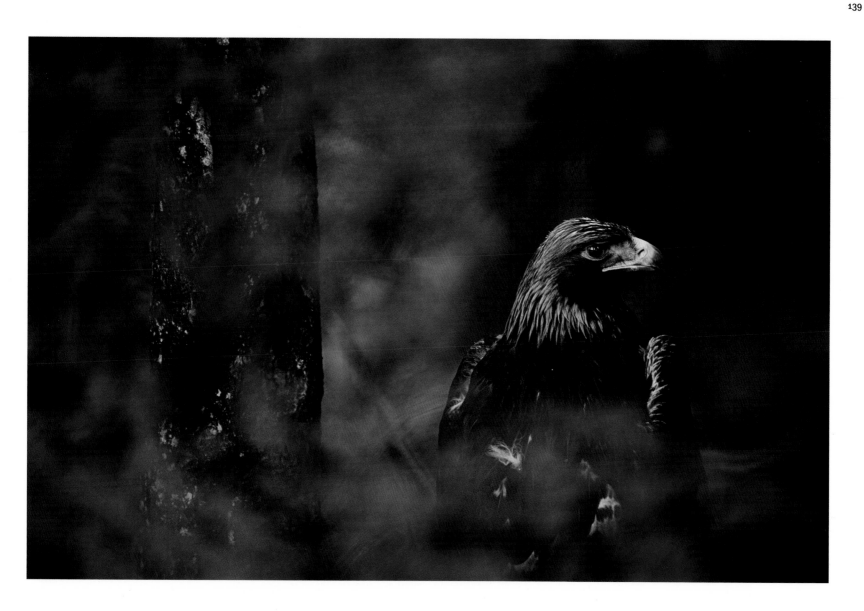

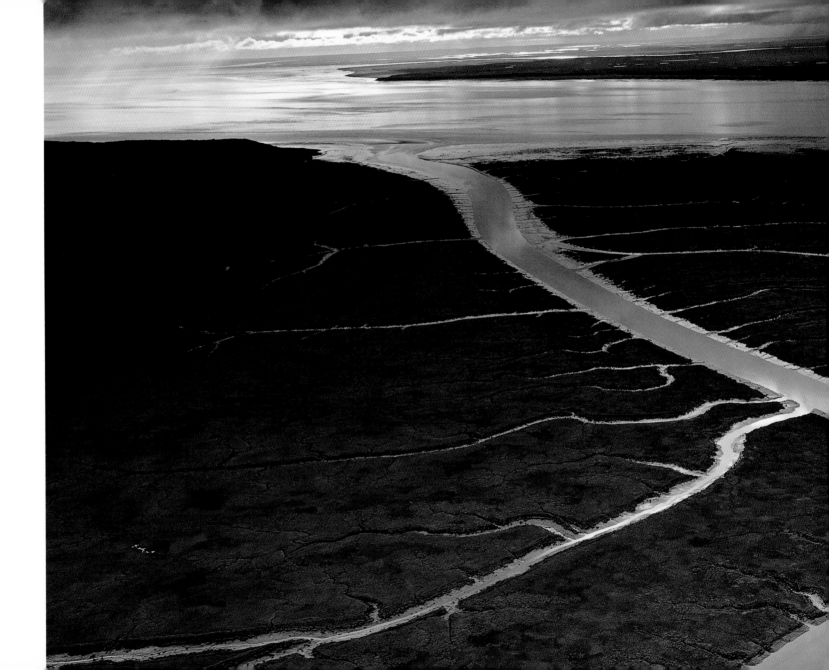

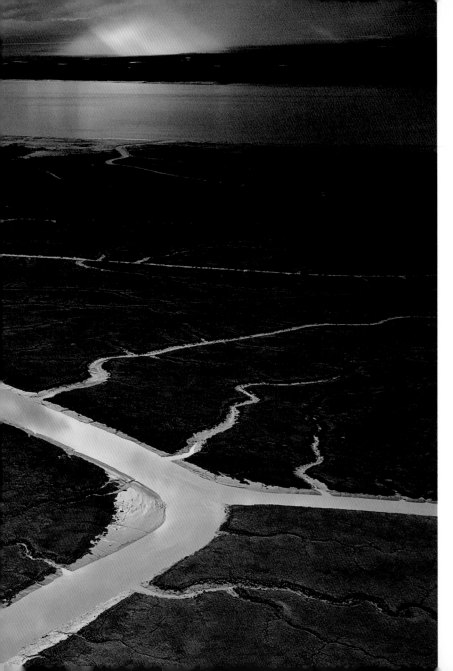

Bristol Bay has a unique hydrology, with the land acting like a giant sponge where water travels both underground and above.

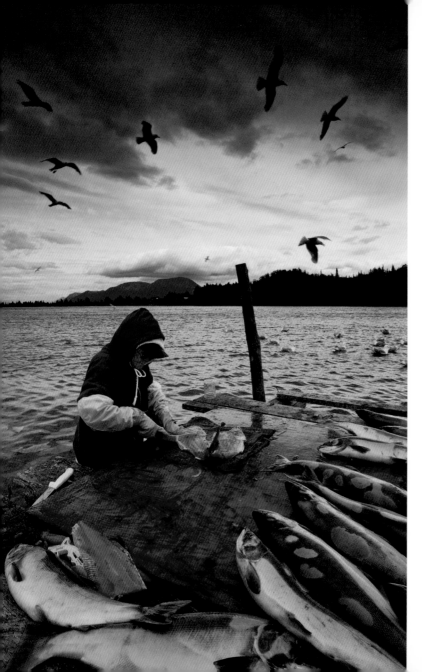

May Alexie fillets sockeye salmon at Nondalton's "Fish Camp" on Sixmile Lake while gulls circle overhead hoping for scraps.

Opposite: The native tribes around Bristol Bay have dried and smoked salmon for generations in order to survive the long winter months.

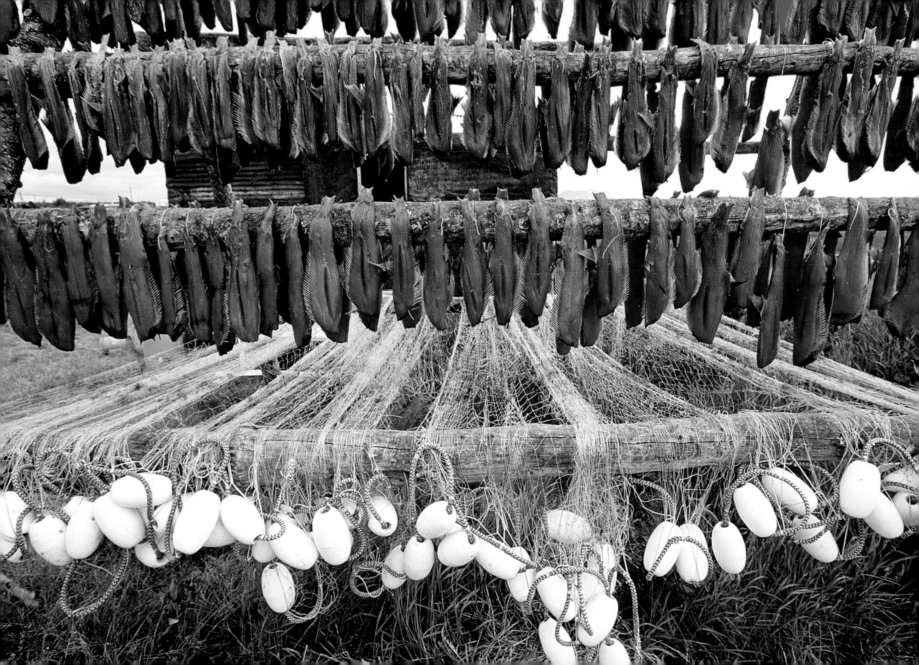

"We love our fish," says Ina Bouker, a Yupik and
teacher from Dillingham who opposes the mine.
"The salmon always run. But if their habitat is
destroyed, they will not come back."

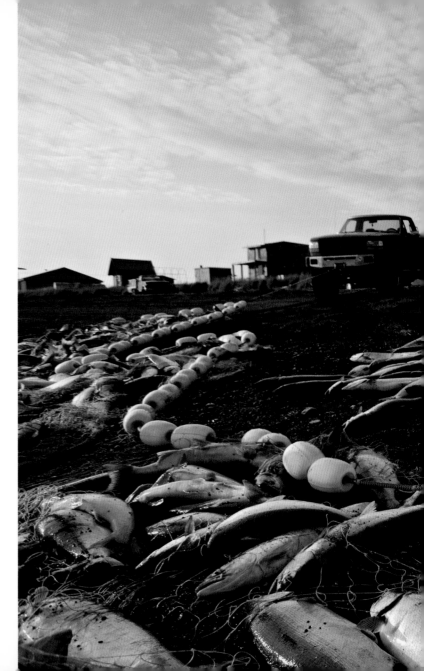

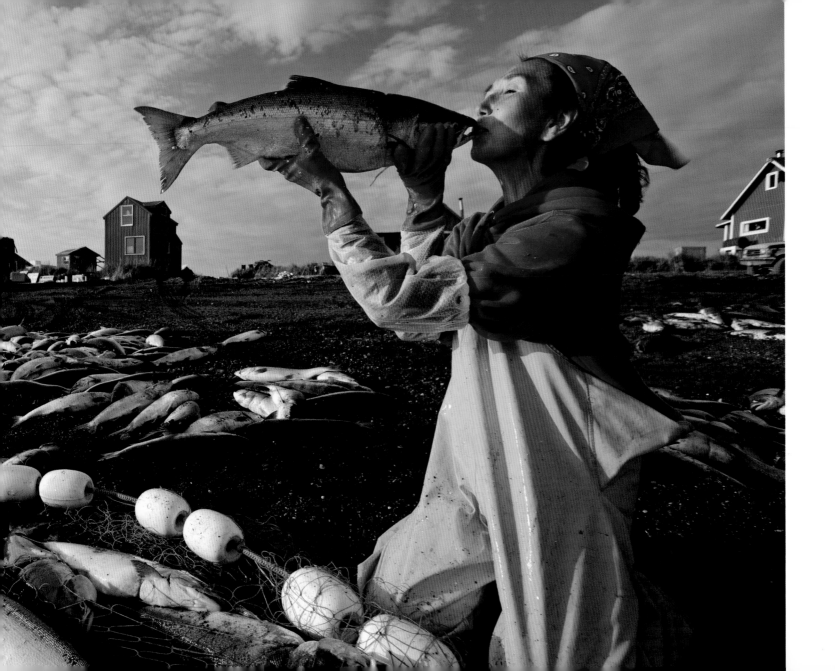

Like his Dena'ina ancestors, Luther Hobson checks the status of salmon in his smokehouse. In his village, Nondalton, most residents favor their traditional subsistence lifestyle over the promise of mining jobs.

Following pages (148-149)
The sun sets on Lake Aleknagik, north of Bristol Bay. The bay and its surrounding area are some of the most stunning wilderness still preserved in the United States.

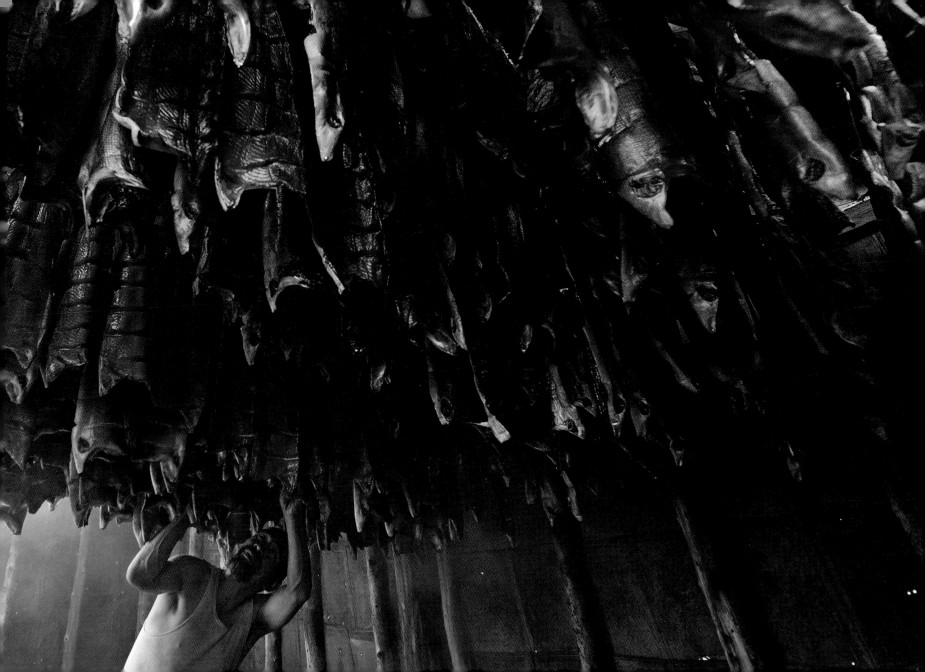

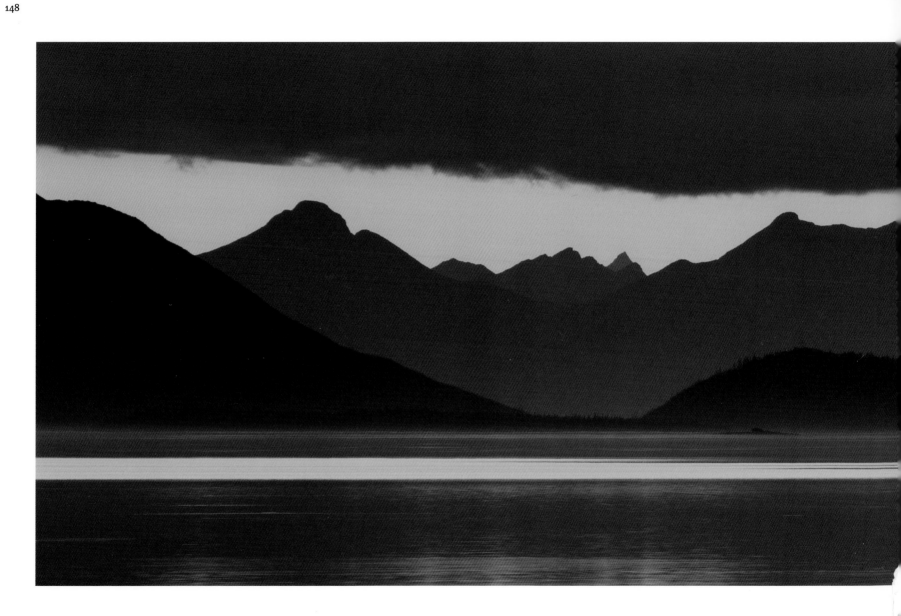

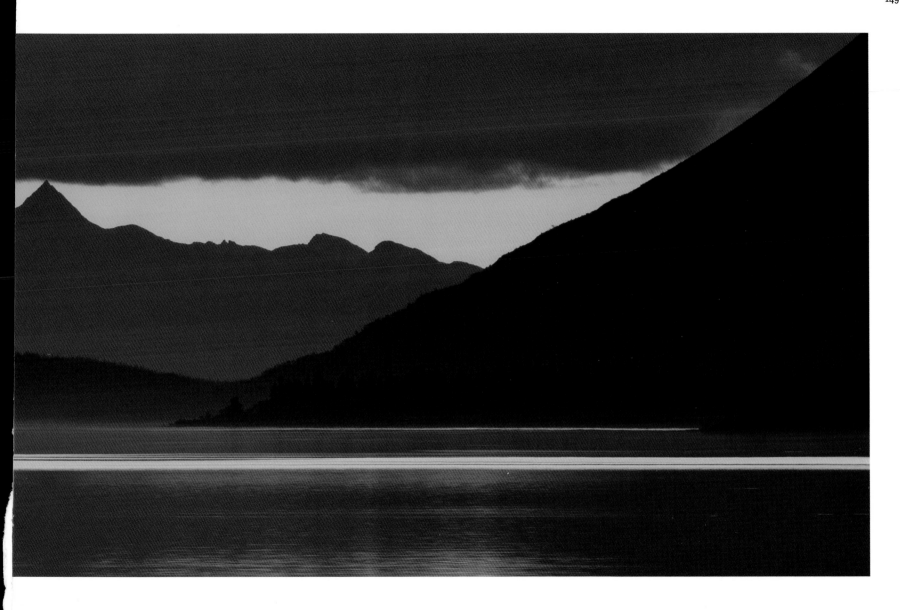

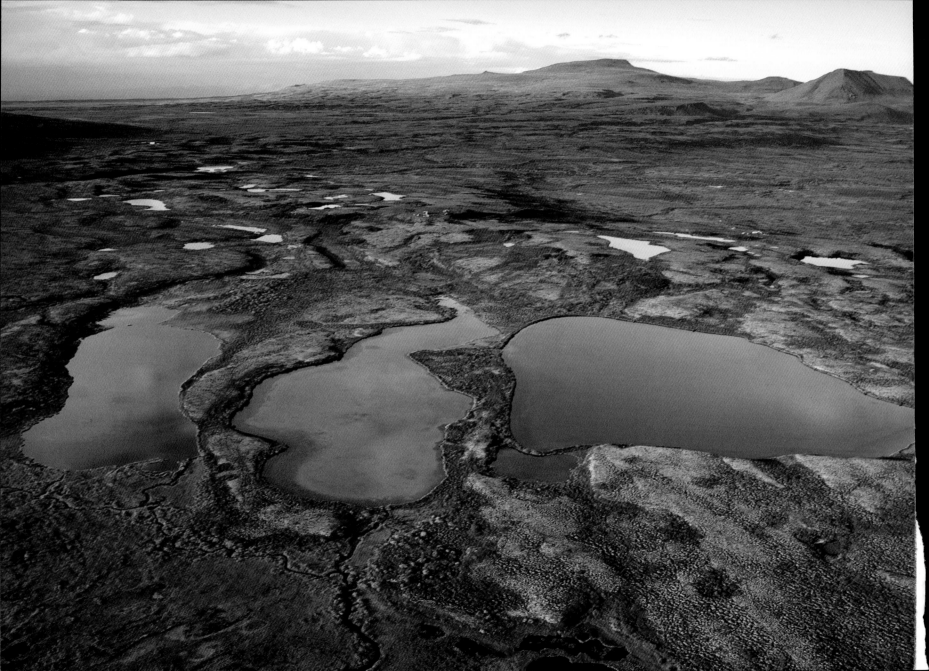

Corporate interests have proposed a massive mining operation to unearth the rich deposits of gold, copper, and molybdenum under the land in this region.

Bristol Bay stands today as an emblem of all that is wild, productive, and pure—a land that until now has remained immune to the many ravages of industrialization. But today this land of extreme salmon teeters at a precipice. For along with a thriving fishery and its phenomenal array of wildlife and waterfowl, this area is also rich in natural resources. Just under the surface of this beautiful landscape lies a newly discovered body of ore that may reveal the world's largest deposit of gold and one of the largest deposits of copper. Currently a team of two companies, the Pebble Partnership, proposes a massive open-pit mine and an equally large underground mine in the region.

According to Pebble Project spokespeople, more than $350 billion worth of valuable metals lie beneath these lands, and mining them will bring jobs to people now desperately in need of improving their livelihoods. The massive mine proposed at the headwaters of the Nushagak and Kvichak Rivers would likely be the largest in North America, and it may be only the beginning. Several other large companies have claims in the nearly thousand-square-mile area currently open to mining.

Plans submitted in 2006 show a pit nearly two miles long and a mile and a half wide. Seventy million gallons of water per day would be extracted from nearby streams, and up to seven billion tons of waste rock, some toxic, would be stored underwater in holding lakes created by earthen dams. Early plans called for the largest of these to measure 4.3 miles long and 720 feet high, larger than Hoover Dam and taller than Seattle's Space Needle.

Estimates of the required electricity keep rising, the latest figure between 500 and 600 megawatts annually—the same amount used by Anchorage, a city of 280,000. A deepwater port on Cook Inlet and a 104-mile road to the mine site, crossing as many as 120 streams, including the Newhalen River, would also be built. Along this road would run a pair of slurry lines, one to send

EPILOGUE

partially milled ore to ships and one to send leftover slurry back to be stored in perpetuity on site.

Rick Halford, bush pilot and past state senate president, says he went to the capital with a positive attitude toward mining. "I'm a conservative," he proclaims, "completely pro-development and was endorsed by the Alaska Miners Association. But the more I looked, the more I learned, the more horrified I became, because of the size, type, and scope of the mining, but more than anything the location.

"Throughout my career in the senate I pushed for every mining project and always believed they could be managed, but not this time. No level of active management can protect an area like this," he says. "The reason Alaska is what it is and has what it has is because of what the salmon bring upstream."

Located within the Ring of Fire, the site is surrounded by volcanoes and prone to earthquakes. Many worry that in the event of a large disturbance, the integrity of earthen dams could be jeopardized, resulting in a catastrophic spill. Mining officials early on touted dams that could withstand an earthquake of magnitude 7.8. Alaska experiences magnitude 6 and 7 earthquakes at least five times a year and a magnitude 8 about every 13 years. The Good Friday quake that rocked Alaska in 1964 measured over 9.

Of more concern is the slow leaching of toxins. The same volcanoes that shaped this land deposited minerals that formed sulfide rock, which, when extracted in the mining process and exposed to air and water, becomes sulfuric acid, a deadly toxin that pollutes in the form of acid mine drainage and frees heavy metals like lead and mercury, which even at low levels threaten the health of people and fish. In the entire history of mining, no sulfide mine has not contaminated the ground and surface water around it.

The proposed mine will unearth not only gold but also copper. Recent studies have shown that even trace

amounts of copper can severely affect a fish's olfactory senses. Salmon depend upon their keen sense of smell to find their natal streams, to feed, and to mate.

Free-spirited Alaskans are inherently wary of regulation. "When Lake Clark was made a national park and preserve, people were incensed," reports Clark Whitney, Jr., who has long trapped and fished in Bristol Bay. "We were used to having unfettered access to the land and we were worried. But now, 30 years later, I see it differently. There's a need to protect and preserve what we have here."

Ironically, in 1972 the state did enact protection against the threat perceived by oil and gas exploration with the Bristol Bay Fisheries Reserve. "But it's not enough," says Bobby Andrew, a native leader from Bristol Bay. "We've lived here many thousands of years. Many neighbors and villages in the region need the salmon, and they need to preserve them for the future generations. And it's not just salmon. We also need to protect the waters. We need clean water to survive."

"It will take a huge effort," says fisheries biologist Carol Ann Woody. "We need to change our behavior if we really want salmon for generations to come. It is always easier to conserve than to try and restore a fishery later, especially one as sensitive and complex as this."

Looking at the changing face of our landscape and our fisheries, many Alaskans and other Americans have begun asking important questions when it comes to this vital resource, indeed a bellwether of the health and well-being of our very society. We are finally recognizing what has happened elsewhere—that 350 salmon runs, for instance, are now extinct throughout the Pacific Northwest. And we are coming to the realization that we can set an example in Bristol Bay, finding a wise and graceful way to balance the power and beauty of nature with the opportunities, threats, and demands of the modern world.

THANK YOU

Special thanks to Anders Gustafson, Rick Halford, and Carol Ann Woody. Michael Melford also thanks all who have helped him in Alaska, including Brian Delay, Bobby Andrew, Brian Kraft, the Williamses of Pile Bay, Sue Flensburg, Luki Aklekoh, the Carscallens, Mark Emery, Lindsey Bloom, the Blakeys, Nick Hall, Nondalton Tribal Council, Ina Bouker, Luther Hobson, Nick Jackson, Rainbow King Lodge, Chris Boyer, Lighthawk, Larry Swanson, Bella Hammond, Edwin Dobb, Kurt Mutchler, Tim Bristol, Lauren Oaks, and Nan Elliot. Dave Atcheson also thanks Kristin DeSmith, Tony Lewis, Samuel Snyder, Melanie Brown, Paul Tornow, Marge Mullen, and Clark Whitney, Jr., as well as Mr. Robert B. Gillam and the Renewable Resources Coalition and Renewable Resources Foundation boards.

RESOURCES

Bristol Bay Alliance, www.bristolbayalliance.com

Bristol Bay Regional Seafood Development Association, www.bbrsda.com

Conservation International, www.conservation.org

Earthworks, www.ourbristolbay.com

National Wildlife Federation, www.nwf.org

Natural Resources Defense Council, www.nrdc.org; www.savebiogems.org/bristolbay/

Nature Conservancy, www.nature.org

Nature Conservancy Alaska, www.nature.org/wherewework/northamerica/states/alaska/

Nunamta Aulukestai "Caretakers of the Land," www.nunamta.org

Pebble Partnership, www.pebblepartnership.com

Renewable Resources Coalition, www.renewableresourcescoalition.org

Trout Unlimited, www.tu.org

World Wildlife Fund, www.wwf.org

HIDDEN ALASKA

Photography by Michael Melford
Text by Dave Atcheson

Published by the National Geographic Society

John M. Fahey, Jr., *President and Chief Executive Officer*
Gilbert M. Grosvenor, *Chairman of the Board*
Tim T. Kelly, President, *Global Media Group*
John Q. Griffin, *Executive Vice President; President, Publishing*
Nina D. Hoffman, *Executive Vice President;*
 President, Book Publishing Group

Prepared by the Book Division

Barbara Brownell Grogan, *Vice President and Editor in Chief*
Marianne R. Koszorus, *Director of Design*
Susan Tyler Hitchcock, *Senior Editor*
Carl Mehler, *Director of Maps*
R. Gary Colbert, *Production Director*
Jennifer A. Thornton, *Managing Editor*
Meredith C. Wilcox, *Administrative Director, Illustrations*

Staff for This Book

Linda B. Meyerriecks, *Project Editor and Illustrations Editor*
Lincoln Michel, *Text Editor and Contributing Writer*
Sanaa Akkach, *Art Director*
Judith Klein, *Production Editor*
Matt Chwastyk, Mike McNey, and XNR Productions,
 Map Research and Production
Mike Horenstein, *Production Manager*
Robert Waymouth, *Illustrations Specialist*
Lindsey Smith, *Design Intern*

Manufacturing and Quality Management

Christopher A. Liedel, *Chief Financial Officer*
Phillip L. Schlosser, *Senior Vice President*
Chris Brown, *Technical Director*
Nicole Elliott, *Manager*
Rachel Faulise, *Manager*
Robert L. Barr, *Manager*

The National Geographic Society is one of the world's largest non-profit scientific and educational organizations. Founded in 1888 to "increase and diffuse geographic knowledge," the Society works to inspire people to care about the planet. National Geographic reflects the world through its magazines, television programs, films, music and radio, books, DVDs, maps, exhibitions, live events, school publishing programs, interactive media and merchandise. *National Geographic* magazine, the Society's official journal, published in English and 32 local—language editions, is read by more than 35 million people each month. The National Geographic Channel reaches 320 million households in 34 languages in 166 countries. National Geographic Digital Media receives more than 13 million visitors a month. National Geographic has funded more than 9,200 scientific research, conservation and exploration projects and supports an education program promoting geography literacy. For more information, visit nationalgeographic.com.
For more information, please call 1-800-NGS LINE (647-5463) or write to the following address:

National Geographic Society
1145 17th Street N.W.
Washington, D.C. 20036-4688 U.S.A.

For information about special discounts for bulk purchases, please contact National Geographic Books Special Sales: ngspecsales@ngs.org

For rights or permissions inquiries, please contact National Geographic Books Subsidiary Rights: ngbookrights@ngs.org

The Renewable Resources Coalition, the Alaska affiliate of the National Wildlife Federation, was founded in 2005 with the mission to protect the ongoing viability of Alaska's fish and game resources and the lands and waters upon which they depend.

Renewable Resources Coalition
605 West Second Avenue
Anchorage, Alaska 99501
907-743-1900
For More Information:
www.renewableresourcescoalition.org
or:
www.renewableresourcesfoundation.org

ISBN: 978-1-4262-0770-9

Printed in China

10/PPS/1